M000236884

SARATOGA
RACE
COURSE

SARATOGA RACE COURSE

The August Place to Be

KIMBERLY GATTO

THE
History
PRESS

Published by The History Press
Charleston, SC 29403
www.historypress.net

Copyright © 2011 by Kimberly Gatto
All rights reserved

Front cover: photo by Jessie Holmes; drawing, inset, Library of Congress.
Back cover: *top, left to right*: Jessie Holmes, Library of Congress, Jason Moran; *bottom*:
Jessie Holmes.

First published 2011

ISBN 978.1.54020.525.4

Library of Congress CIP data applied for.

Notice: The information in this book is true and complete to the best of our
knowledge. It is offered without guarantee on the part of the author or The History
Press. The author and The History Press disclaim all liability in connection with the
use of this book.

All rights reserved. No part of this book may be reproduced or transmitted in any form
whatsoever without prior written permission from the publisher except in the case of
brief quotations embodied in critical articles and reviews.

In Memory of
Black Tie Affair
(1986–2010)
A noble and courageous champion

Photo by Matt Wooley.

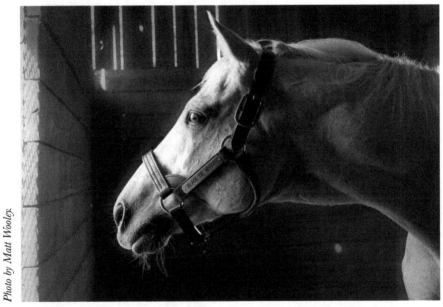

1991 Horse of the Year
Originally purchased at the Saratoga Yearling Sales

CONTENTS

Introduction, by Michael Blowen 9
Foreword, by Alex Brown 13
Acknowledgements 15

1. History of Horse Racing in New York 17
2. The Place of Swift Water 25
3. The Pugilist 33
4. A World-Class Racecourse 39
5. Early Years 45
6. A New Beginning 53
7. "The Mostest Hoss" 65
8. The Roaring Twenties 71
9. The Fox, the Biscuit and the Admiral 75
10. Wartime and Winners 83
11. The Age of Media 87
12. One Hundred Years of Greatness 93
13. A Tale of Two Champions 101
14. Talk of the Town 107
15. Fan Favorites 113
16. Saratoga's Old Friends 119
17. The New Millennium 127
18. Rachel and Beyond 137

CONTENTS

Afterword. History of the National Museum of Racing,
 by Brien Bouyea 143
Appendix A. Stakes Races as of 2010 147
Appendix B. Winners of the Travers Stakes 149
Appendix C. Winners of the Whitney Handicap 159
Appendix D. Winners of the Alabama Stakes 165
Notes 171
About the Author 175

INTRODUCTION

The night before the Saratoga racing meet opened every year, I found myself on the front porch of the Washington Inn looking for the winners camouflaged in the *Daily Racing Form*. For weeks ahead of each meet, I studied John Angelo's Saratoga primer the way my grandmother digested the New Testament. That's when my only relationship with the sport was Beyer Speed Figures, track bias, win early sires and pace numbers. It was all about cashing tickets. That's when I only thought about picking winners. That was all about to change.

It was the summer of 2003. I had just resigned as operations director for the Thoroughbred Retirement Foundation to concentrate on writing a book about my experiences as a bettor, horse owner, groom, hot walker and convert to Thoroughbred retirement. The mathematical puzzles presented by each race had been replaced by a much larger picture, like going from a snapshot to Cinerama. What obligations did we have to our athletes? How could it be that they earned all the money and retired with no 401K or Social Security? How could these majestic creatures be considered so disposable?

Joe Bokan, energetic proprietor of the Washington Inn, emerged from fixing the automatic sprinkler that kept his purple and red hanging plants so healthy. He brought me a bottle of Saratoga Lager.

"What's the matter?" he asked.

I had no idea, at first, what he was talking about.

"What do you mean?"

"You're not smiling."

I looked back at the *Daily Racing Form* and it suddenly occurred to me. I had just handicapped the third race and there was a promising two-year-old by a sire whom I knew met a bad end.

Then I got on my soapbox.

"These horses do everything for us," I said. "Without them, there's nothing. They are the athletes...the artists. And, when they're done racing and breeding, what do you do with them?"

Joe listened. "I loved working at the TRF, and they have a great program for retraining geldings and mares and working with inmates. But they are always forced to beg for money. We have to figure out some way that these horses can generate income once their working days are over."

That's when the obvious struck me. I decided to start a Thoroughbred retirement facility that would not duplicate what so many other groups were doing so well. The retired horses were done competing, and so was I. We would concentrate on retiring the stars of the sport—copying that idea from the Kentucky Horse Park—and open the farm up for visitors. We'd specialize in taking stallions and establish a tourist destination. At the time, we had no farm, no horses and no money.

"That's a great idea," Joe said. "Do it."

A few months later, back home in Midway, Kentucky, I was looking through Barbara Livingston's marvelous book with evocative photographs and precise writing about visiting her favorite retired Thoroughbreds. The book is called *Old Friends*. Within a week, Barbara and Eclipse Press had given me permission to use the name "Old Friends." We still had no farm, no horses and no money. But I knew Joe was right. If the fans of these great athletes would support them in their dotage, we might be on to something. It worked.

Now, we support more than one hundred Thoroughbreds (and Little Silver Charm, our mascot mini) at farms in Georgetown, Kentucky, and Greenfield Center, New York. Travers winners Thunder Rumble and Will's Way, along with two-time Whitney winner Commentator, Hopeful victor Crusader Sword and Sword Dancer winners Kiri's Clown and Awad, call Old Friends home. We've brought five stallions home from Japan: Creator, Sunshine Forever, Fraise, Ogygian and Wallenda. We have Eclipse Award winners Gulch, the Wicked North and Hidden Lake, and the great ones that called Old Friends home during their final days include Precisionist, Black Tie Affair, Ruhlmann, Ballindaggin, Polish Navy and Jade Hunter.

INTRODUCTION

The legacy of Saratoga Springs, as so adroitly chronicled by Kim Gatto, lives within these pages. And while I saw Awad set the track record in the 1995 Sword Dancer and Hidden Lake's courageous performance in the Go for Wand, my greatest memory of the greatest racing venue in America is sitting on the front porch of the Washington Inn, finishing that Saratoga Lager and dreaming of Old Friends. Most dream of owning a Derby winner, but that dream can only come true once a year. Mine happens every day.

Michael Blowen
Founder and President, Old Friends

FOREWORD

E ach summer, the best horses from Kentucky and the East Coast converge
at Saratoga Race Course and compete during the height of the racing
season. Kimberly Gatto unlocks the mysteries of Saratoga by taking us on a
wonderful journey through its unique history. She details its beginning, born
out of a need to support other gambling enterprises, and rising to its status
on the racing circuit as the "August place to be."

Along the way, readers are introduced to some of the greatest horses in
our sport and how winning races at Saratoga is an important addition to
their credentials. But we also learn how Saratoga has earned its alternate
tagline: "the graveyard of champions." How else does one explain the losses
of arguably the two greatest racehorses to ever grace the turf in North
America, Man o' War and Secretariat?

Saratoga was also the venue of many of the great wins of some of the
highly regarded "iron horses" of our sport, including Exterminator, who
won four consecutive runnings of the Saratoga Cup, and five-time Horse of
the Year Kelso, who won his third Whitney Handicap at the age of eight.
And Kimberly lets us not forget another unlikely star, Roamer, a horse that
was not meant to be but went on to win thirty-nine races in a career spanning
seven years.

Throughout its illustrious history, Saratoga has been a place of leisure for
politicians, famous athletes and movie stars. Singer Bing Crosby founded Del
Mar Racetrack as a result of his experiences at Saratoga. While horse racing,
as a sport, has lost some of its luster with the growth of other professional

sports, the meet at Saratoga still attracts the elite, drawn by the magical experiences provided by our best horses in an idyllic setting—experiences that offer an escape from the regular grind of life.

For any historian or fan of our sport, *Saratoga Race Course: The August Place to Be* is an essential read. We are reminded of the stars of yesteryear while also realizing how important Saratoga has been to some of our more contemporary stars like Rachel Alexandra. Kimberly has done a wonderful job of weaving together a remarkable journey made up of the who's who of the racing turf. It is a journey that any racing fan will enjoy.

Alex Brown
Author, *Greatness and Goodness: Barbaro and His Legacy*

Acknowledgements

The author would like to thank the following for their contributions to this book:

Michael Blowen, the wonderful founder and president of Old Friends, for suggesting that I write about Saratoga Race Course and for sharing his vast knowledge throughout the process;

Alex Brown, fellow author and friend, for offering valuable feedback and support;

Brien Bouyea and the staff of the National Racing Museum and Hall of Fame, for providing excellent suggestions as well as photographs;

Jessie Holmes, Bud Morton, Adam and Bob Coglianese, Cindy and Terence Dulay, Jason Moran, Rick Capone, Wendy and Matt Wooley, John Bellucci, Connie Bush and Walter Kobbe, as well as Phyllis Rogers of the Keeneland Library, for allowing me to use their wonderful photographs and for ensuring that I had all of the photographs that I needed;

Allison Pareis, for providing the beautiful illustrations and contributing terrific ideas, as well as friendship;

Vivien Morrison, Tim Ford, Susan Salk, Dawn Denningham and Patrick Lennon, for contributing feedback on the manuscript;

Whitney Tarella, Hilary McCullough and Dani McGrath of The History Press, for their support throughout the project;

all of my family members and friends;

my lovely horse, Grace, and my late mare, Chutney, who instilled in me a great appreciation and love for thoroughbreds; and

my mom, Ann Urquhart, who has always believed in me as a writer, horsewoman, daughter and friend.

Chapter 1

HISTORY OF HORSE RACING
IN NEW YORK

L ong before Saratoga was "the August place to be," horse racing in North America began in the area now known as Nassau County. In fact, much gratitude is owed to King Charles II of England, who opted to bring his "sport of kings" to North America—and, in particular, New York.

Charles, affectionately referred to as the "Merry Monarch," enjoyed life to the fullest. He was passionate about horse racing, spending the spring and summer months in the bustling equestrian town of Newmarket. The king so loved the area that he moved his entire court from London to Newmarket for the spring and fall races each year. He ordered construction of a palace on top of a hill that offered an illustrious view of Newmarket's daily races and workouts.

In 1665, Charles established the Town Plate, the oldest surviving thoroughbred race in history and the first to be run under written rules. An accomplished competitive rider, Charles actually won the race on his own horse in 1671. Around that time, the king created a stretch of turf that faced away from the sun, as its harsh rays bothered his sensitive eyes. The new stretch was named "the Rowley Mile" in honor of Charles's favorite mount, the stallion Old Rowley. (The nickname "Old Rowley" was also used in jest to describe the king himself, owing to his reputation as a ladies' man.)

With the arrival of British settlers in America in the 1600s, Charles instructed Richard Nicolls, the colonial governor of New York, to develop

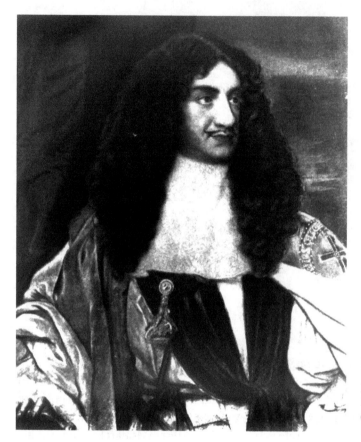

Charles II of England, also known as "Old Rowley." *Courtesy of the Library of Congress.*

a racetrack on the Salisbury Plains (located on what is now the Hempstead Plains on Long Island). The new course, while lacking the splendor of its UK namesake, was christened "Newmarket" at Charles's insistence. The first race at the "new" Newmarket was held during 1665 and was overseen by Governor Nicolls. It is not known how long racing continued at this new track; however, there remains a plaque in Garden City, Long Island, that marks the site of the Newmarket course. Incidentally, the track was situated just a few miles away from what is now New York's legendary Belmont Park.

Over the next 150 years, various small courses were established by wealthy horse owners in the New York area. These were privately owned tracks that were used for recreation rather than as business ventures, although wagers on the races were frequently made. In 1802, the State of New York placed a ban on horse racing in an effort to curtail gambling. The ban was removed in 1819 and reimposed the following year but was lifted for the Queen's County area in 1821.

Coinciding with the removal of the ban, Union Course was established for thoroughbred racing in Woodhaven, Queen's County. It was, according to the *New York Times*, "for about 50 years, practically the racing centre for the territory around New York."[1] Union Course offered the first "skinned," or dirt, track surface—a novelty at that time, as the races in Britain were run on grass, or turf. There are several possible explanations for the conversion to dirt, including the belief by some that it would allow for higher speeds, and sheer convenience, as dirt was much easier to maintain than grass in the dry U.S. climate.

Union Course was "one mile in circuit, and so well laid out that it was used as the model for many of the big running and trotting tracks in other parts of the country," as noted in the *Times*. As there was no grandstand on the premises, spectators watched the races from vantage points such as trees or spread out along the sides of the track. The course was designed to showcase the four-mile heat races that were common at that time.

Match races, which typically pitted a horse from the North against a rival from the South, were highly touted events at Union Course, often drawing large crowds. One of the most famous was a race between the northern favorite, the nine-year-old American Eclipse, and three-year-old Sir Henry, the pride of Virginia. The race consisted of three four-mile heats, with the stakes set at $20,000. American Eclipse, a son of the undefeated English stallion Eclipse, had actually been retired to stud at the age of six following a successful racing career. In order to generate publicity for the recently established Union Course, his owner, Cornelius W. Van Ranst, brought the stallion back into training.

The American Eclipse/Sir Henry matchup, held on May 27, 1823, attracted more than sixty thousand spectators. Some traveled as far as five hundred miles to watch the race. Those in attendance included many members of Congress, future U.S. president Andrew Jackson (at that time serving as governor of Florida), Vice President Daniel Tompkins and former vice president Aaron Burr. Sir Henry, younger than American Eclipse by six years and having raced more recently, was deemed the odds-on favorite.

Sir Henry did not disappoint in the initial heat, setting a course record of 7:32½ while defeating his older opponent and, according to the book *The Neighborhoods of Queens*, "causing a panic in the New York Stock Exchange."[2] American Eclipse rebounded, however, outrunning Sir Henry in the next two heats and ultimately winning the match. Some spectators had a particularly adverse reaction to Sir Henry's defeat. *The Neighborhoods of Queens* reported that American Eclipse's victory "saved the Stock Market from collapse but

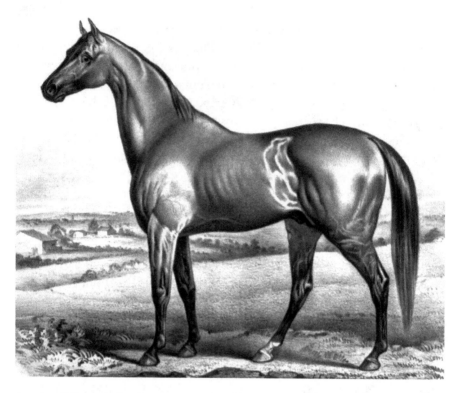

American Eclipse, winner of a key match race at Union Course. *Courtesy of the Library of Congress.*

led several southerners, who had bet their entire plantations on Sir Henry, to commit suicide on the spot."

By 1825, racing had surged through other areas of New York—including Saratoga Springs—albeit in a less formal manner. Riders often raced through the city streets, creating a danger for city dwellers. As a result, the activity was banned by city officials, although, according to local lore, efforts to curtail it were not always successful. Meanwhile, the popularity of horse racing continued to climb. William Blane, a traveler from England, commented in his journals that the sport "roused more interest than a presidential election."[3]

There were approximately 130 meets for thoroughbreds throughout the United States by 1836, and sales of racing horses averaged $500,000 annually. As the sport thrived, Union Course continued to showcase outstanding athletes. In 1842, the track hosted a match race between the legendary stallion Boston and the mare Fashion. Boston, named for a popular card game rather than the city, had been given to Nathaniel Rives of Richmond,

Virginia, by breeder John Wickham as repayment for a gambling debt of $800. The game that resulted in Boston's change of ownership was likely the source of the colt's unique name.

A striking chestnut with a white blaze, Boston was often referred to by his nickname of "Old Whitenose." He was well known for his difficult temperament, which led noted horseman Colonel L. White to suggest that the horse be "either castrated or shot, preferably the latter."[4] At one point, he developed the habit of dropping and rolling with a rider on his back. He also refused to finish a race on at least one occasion.

Difficult temperament notwithstanding, Boston could run. As a six-year-old, he raced nine times, winning all but one start. It is rumored that at the height of Boston's career, his then owner, Colonel W.R. Johnson (known by some as the "Napoleon of the Turf"), was actually paid to keep the colt out of certain races so that other horses would stand a chance at winning. Already a successful sire at the age of nine, Boston had covered forty-two mares (at a fee of $100 each) and had been the leading sire in 1841 and 1842. For her part, the five-year-old Fashion was considered the greatest racing mare of the era, having already defeated Boston in October 1841 in the Jockey Club Purse.

Boston and Fashion met at Union Course on May 10, 1842, before a crowd of seventy thousand spectators. Boston carried 126 pounds, while the mare toted 111. The race was eventful from the beginning, with both horses startled by the exuberance of spectators who had spilled onto the track. Spooked by the raucous crowd, Boston hit the rail early on in the race and sustained a large and jagged wound on his hip. Nevertheless, Old Whitenose led for the first three miles before being passed by Fashion nearly sixty yards into the final turn. The filly set a new world record of 7:32½ for the four-mile match, a record that would remain unbroken for thirteen years.

While many fans called for a rematch, it would never occur. Boston continued his career as a breeding stallion, retiring from racing with a record of 40-2-1. He would go on to sire some of the greatest horses of the time, despite succumbing to blindness and a host of other physical maladies. Among Boston's last foals, born after his death in 1850, were the great Lexington and Lecompte.

Fashion returned to the Union Course on May 15, 1845, for a duel with an undefeated southern mare called Peytona. Fashion, the smaller of the two horses, carried 123 pounds, while her larger opponent carried a mere 116 pounds. Fashion was not at her best that day, leaving Peytona the victor in

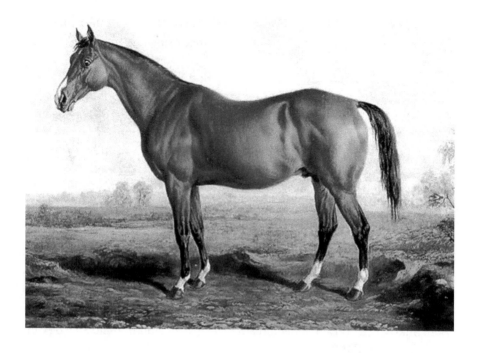

The celebrated stallion Lexington was one of Boston's greatest offspring. *Courtesy of the Library of Congress.*

straight heats. Unbeknownst to the 100,000 folks in attendance, the Fashion-Peytona showdown would be the last great match race held at Union Course. Despite the loss to Peytona, Fashion retained her reputation as one of the greatest mares of her time. In sixty-eight career heats, she would lose only thirteen.

The years following the Fashion-Peytona race witnessed an increase in the popularity of trotting horses in New York. A trotting track, Centreville, had been established in 1845 in Queens County and was well received in the area. In 1847, in conjunction with the New York State Fair, a meet for trotters was established on land adjacent to what is now Union Avenue in Saratoga Springs. The oval track, measuring sixty feet in width, was constructed by local entrepreneurs Alfonso Patten and James Cole. Adjacent to the track were a small grandstand and a stable built of simple boards and planks. The facility was known as the Saratoga Trotting Course. Key horses that raced at this new track included the great Flora Temple and Lady Suffolk, the horse for whom Stephen Foster allegedly penned the folk song "The Old Grey Mare." The latter became the inaugural race winner at the Saratoga

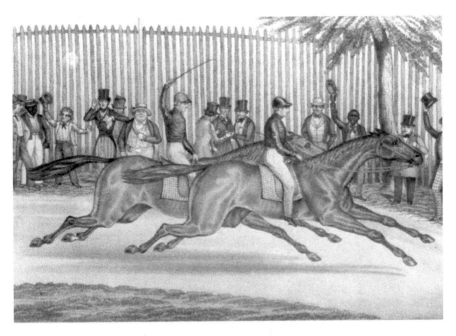

The race between Peytona and Fashion at the famed Union Course. *Courtesy of the Library of Congress.*

The celebrated trotting mare Lady Suffolk at Centreville. *Courtesy of the Library of Congress.*

Trotting Course when she defeated a bay gelding by the name of Moscow on August 14, 1847.

Despite its moniker, trotting horses were not the only racers to appear at the track. Two days after Lady Suffolk's win, on August 16, 1847, a three-heat race was won by the New Jersey–bred Lady Digby, a thoroughbred mare sired by Monmouth Eclipse. The purse was a reported $100. It was the first organized thoroughbred race ever held at Saratoga.

Chapter 2

THE PLACE OF
SWIFT WATER

The area now known as Saratoga Springs traces its roots to Fort Saratoga, which was established in 1691. It was constructed on the west bank of the Hudson River (south of the area now known as Schuylerville) during the Nicholson Expedition as a supply post. The area had originally been inhabited by Native Americans, who had discovered the medicinal benefits of its mineral springs as early as the year 1300. The Iroquois, who used the area primarily for fur trading, called it "Sarachtogue," which means "the place of swift water."

In 1767, a group of Mohawk Indians befriended a British soldier by the name of Sir William Johnson, who had been injured in the Battle of Lake George. The Indians brought Johnson to the "Medicine Spring of the Great Spirit," a spring within the center of a cylinder-shaped rock. The cool waters soothed his wounds, and within days Johnson was well enough to walk on his own. The site of Johnson's recovery is now known as High Rock Spring.

Word of Johnson's healing quickly spread, and other war veterans traveled to the area to reap the medicinal benefits of the springs. American colonists began clearing the land and sold its timber, which was distributed via the Hudson River. Tanning mills for producing leather were also established. The area served as the site of many historic battles; however, sources differ as to whether the famous Revolutionary Battle of Saratoga actually occurred on-site or, rather, at nearby Stillwater, approximately fifteen miles south of Saratoga.

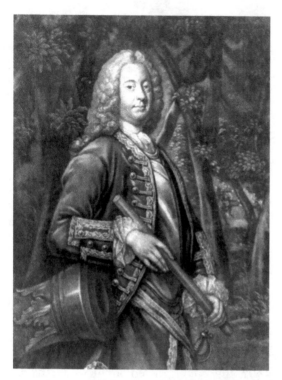

Left: Sir William Johnson was an early visitor to the mineral springs. *Courtesy of the Library of Congress.*

Below: High Rock Spring, circa 1906. *Courtesy of the Library of Congress.*

In 1783, High Rock Spring received a visit from a distinguished group that included Alexander Hamilton, Governor George Clinton of New York and George Washington. The men were guests of General Phillip Schuyler, who had taken up summer residence at the springs. George Washington was reportedly so enthralled with the area that he offered to purchase the land. Much to Washington's dismay, land titles had already been assigned.[5]

As the mineral springs continued to attract new visitors, the first bathhouse was established in 1784. Entrepreneur Gideon Putnam arrived in town in 1789 and within two years had purchased three hundred acres of land. Putnam established the elaborate Grand Union Hotel (originally called Union Hall) in 1802 and began developing further plans for Saratoga as a tourist area. The continuous arrival of wealthy tourists forced Putnam to expand his hotel on at least two separate occasions. Putnam established Congress Hall, another grand hotel, in 1812, but died after a fall from the scaffolding during construction.

By 1819, Saratoga had become a popular tourist destination, competing with other established spa areas, including nearby Ballston Spa. It was also the site, however, of one of the United States' first temperance societies,

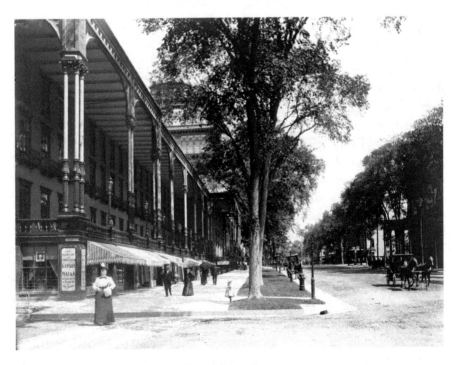

The elaborate Grand Union Hotel. *Courtesy of the Library of Congress.*

Congress Hall in downtown Saratoga Springs. *Courtesy of the Library of Congress.*

and thus alcohol, gambling and dancing were prohibited for some time. As the area's resort business increased, the rules were loosened, and the bans were virtually eliminated by 1820. People were free to gamble and drink to their hearts' content—and they did. Elaborate meals were served, lavish balls were held and exorbitant amounts of money were spent.

Wealthy and fashionable socialites took a liking to the area, particularly in the late summer weeks of July and August, and additional hotels were constructed to accommodate them. Artists and writers found solace in the woods and fishing ponds that surrounded the springs. Politicians flocked to Saratoga, as did various entrepreneurs. In 1825, John Clarke, originator of the first soda fountain in New York, moved into town. Clarke began bottling and selling carbonated mineral water from the springs, generating large profits. By 1826, Saratoga Springs was legally recognized as a village, owing largely to the celebrities and politicians who frequented the region.

The arrival of the railroad in 1831 made access to Saratoga more feasible. A popular spot for prominent guests was the tavern built by Jacobus Barhyte, a Revolutionary War hero. Frequent visitors to the tavern included politicians

John Quincy Adams and Martin Van Buren, King Joseph Napoleon of Spain and writers Washington Irving, James Fenimore Cooper and Edgar Allan Poe. According to local lore, Poe composed at least part of "The Raven" in the woods surrounding Barhyte's tavern in 1842 or 1843; however, historians differ as to whether this was in fact the case. Decades later, land belonging to Barhyte would be purchased by Wall Street financier Spencer Trask and his wife. The Trasks would create Yaddo, a popular working retreat for artists and writers, in 1900.

In the meantime, Saratoga Springs continued to make history. In 1853, Moon's Lake House restaurant introduced the first potato chip. The most widely acclaimed account of the chip's origin states that chef George "Speck" Crum became angry when a customer repeatedly sent back his order of fried potatoes with the complaint that they were too thick. The

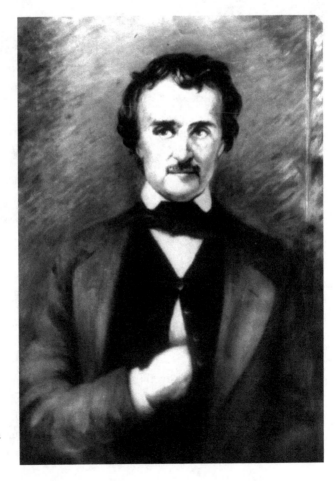

Edgar Allan Poe. Some believe that he wrote "The Raven" while visiting Saratoga Springs. *Courtesy of the Library of Congress.*

The lake surrounding Yaddo, a popular retreat for artists and writers. *Courtesy of the Library of Congress.*

irritated Crum reportedly sliced the potatoes as thinly as he could and added salt to the plate, expecting the customer to react with disgust. To Crum's surprise, the customer enjoyed the new recipe and promptly requested a second helping. Other customers soon began requesting the "Saratoga chips," and a tradition was begun. An alternate version of the tale states that

Crum's sister, Catherine Speck Wicks, was preparing a batch of doughnuts and accidentally dropped some sliced potatoes into the hot grease. Crum allegedly tasted the "chips" and, pleased with the result, added them to his menu. Regardless of the origin of the recipe, Saratoga had begun a new and long-lasting tradition.

The year 1860 ushered in the beginning of the Victorian era in New York. It was a time of continued prosperity, characterized by elaborate architecture and formal events for the elite inhabitants and visitors to the area. Saratoga Springs, in all its splendor, had become a summer meeting place for the famous, the beautiful and the wealthy—similar, in many ways, to Newport, Rhode Island. Ladies enjoyed the spa areas, while men played poker and faro at the various casinos. For several weeks in the summer, the town boasted a virtual who's who of the rich and famous.

Saratoga received its newest visitor in the summer of 1861. Towering at over six feet in height, the dark, bearded man stood out among the elegant masses. Perhaps it was his toughness that belied distinction—his gnarled, boxer's hands and facial scars that could not be concealed beneath a starched broadcloth and linen suit. John Morrissey had arrived, and Saratoga was about to be changed forever.

Chapter 3

THE PUGILIST

J ohn Morrissey was a fighter in every sense of the word. It was a trait that would serve him well—as a young gang member on the streets of New York; in various jobs ranging from "shoulder hitter" to brothel bouncer; and in his rise to national champion prizefighter and politician. Morrissey was gifted with an iron will that propelled him to keep on fighting, regardless of pain or difficulty. In summary, John Morrissey never gave up.

Morrissey was born on February 12, 1831, in County Tipperary, Ireland, to Timothy and Julia Morrissey. Along with many other families, the Morrisseys boarded a ship and immigrated to the United States when their son was just a young child. The family settled in Troy, New York, where Tim Morrissey found work on the docks of the Hudson River, earning a wage of one dollar per day.

A child of poverty, John received his primary education not in the schoolhouse but, rather, on the streets. He earned praise for his roughness and wit, qualities that were virtually essential for a young cargo thief and neighborhood thug. As a youth, Morrissey became the leader of a local gang called "the Downtowns" and was known as the toughest fighter in the area. By the time he was eighteen, Morrissey had been arrested numerous times for acts ranging from burglary to assault with intent to kill. He served two months in prison before leaving Troy for a new life in New York City and a career as a prizefighter.

It was in New York that Morrissey earned the nickname "Old Smoke." At an indoor pistol gallery under the St. Charles Hotel, Morrissey engaged in a

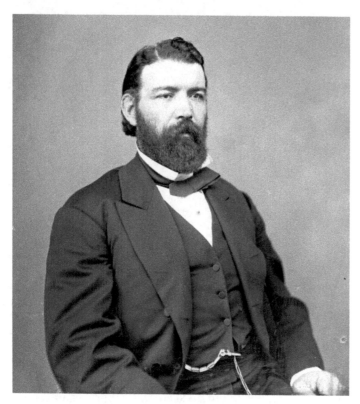

John Morrissey was the mastermind behind the establishment of Saratoga Race Course. *Courtesy of the Library of Congress.*

fight with a local rival named Tom McCann. (According to some sources, the two men were fighting for the affections of a woman.) During the course of the brawl, a stove was overturned, and Morrissey fell backward, landing on a bed of raging coals. Crowds gasped as Morrissey's clothing and flesh caught fire and clouds of smoke rose from his body. Seemingly oblivious to the pain, the brawny Morrissey jumped to his feet; within minutes, he had beaten McCann senseless. From that day forward, John Morrissey was regarded as "Old Smoke."

The incident at the St. Charles Hotel proved Morrissey's mettle. According to the *New York Daily Tribune*, a Morrissey associate had remarked, "John never seemed to know when he was licked, and just as you got tired of thumping him, he kind o' got his second wind, and then you might as well tackle the devil as to try and make any headway against him."[6] He also had a fiery temper. For example, he once attacked a waiter in a dispute over a breakfast bill while dining at a local tavern. When policemen arrived to intervene, he allegedly threatened them as well.[7]

Morrissey's pugnacious attitude impressed area crime bosses. At the Empire Club, a bar operated by Tammany Hall politician Captain Isaiah Rynders,

The Pugilist

Morrissey frequently fought with other guests. Rynders found this trait to be desirable and hired Morrissey as a "shoulder hitter" and immigrant runner for his boardinghouse. Tasks included using threats of violence to gain votes for a particular politician and "persuading" immigrants—sometimes with force—to cast votes for the Tammany Hall candidate. In addition to his fighting spirit, John Morrissey was ambitious. At the age of nineteen, while working as a brothel bouncer, he taught himself to read and write.

Morrissey left New York for San Francisco at the height of the California Gold Rush by stowing away on a steamship. His skills as a poker player earned him a sizable fortune, as he constantly outsmarted prospectors at the card table. Morrissey established a faro business, based on a popular card game originally created in France. It was a highly profitable effort, resulting in a substantial bank roll for Old Smoke. While in California, Morrissey returned to the boxing ring in a fight against George Thompson, the reigning California champion. The first ten rounds were composed, by all appearances, of a virtual mauling of Morrissey by the state champ. Then again, Morrissey was no average opponent. Battered and beaten, he refused to surrender and, in fact, appeared to gain strength with each successive blow. Twenty-two minutes into the fight, referees handed the victory to

Faro, a popular card game in the mid- to late 1800s, was a source of profit for John Morrissey. *Courtesy of the Library of Congress.*

Morrissey following two deliberate fouls by Thompson. Morrissey became the new California champion and gained a large national following.

On the heels of his victory, Morrissey returned to New York City and agreed to take on James Ambrose, aka "Yankee," Sullivan for the U.S. title. Sullivan, despite being an Irish immigrant, always wore an American flag around his waist, earning himself the nickname "Yankee." The fight between Morrissey and Sullivan took place on October 12, 1853, at Boston Corners, near the border of Massachusetts and New York. This location was chosen to reduce the risk of police attendance, as prizefighting in the United States was outlawed at that time. A crowd of nearly three thousand was on hand to watch the brawl.

Morrissey had a significant height and weight advantage over Sullivan and was younger than his rival by eighteen years. Despite such odds, the more experienced Sullivan battered Morrissey for thirty-six rounds. Yet anyone familiar with John Morrissey knew that giving up was all but impossible for him; in round thirty-seven, he would make that quite clear. When Sullivan stepped back for a moment, Morrissey pushed him against the ropes and began to choke him. It was a legal move, according to the rules, and Morrissey used it to his advantage. As Sullivan struggled to breathe, one of his backers entered the ring and promptly pushed Morrissey to the ground, drawing a foul. The crowd went wild, and chaos ensued. The referee attempted to gain control by calling the two fighters to return to the "scratch line." When Sullivan failed to obey, the championship was handed to Morrissey.

Not everyone agreed with Morrissey's victory. One such person was William Poole (aka Bill the Butcher),

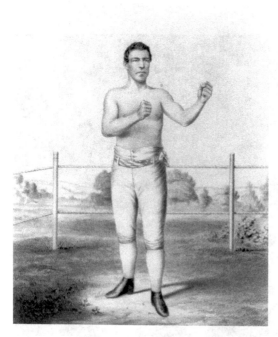

Currier & Ives lithograph from John Morrissey's boxing days. *Courtesy of the Library of Congress.*

the head of a rival gang (representing the Know-Nothing political party) and Morrissey's chief rival. Poole allegedly beat Morrissey in a fight in the summer of 1854 at Amos Dock, New York, and Old Smoke was hungry for revenge. In February 1855, Poole was shot by policeman Lew Baker, a close friend of Morrissey's, at Broadway's Stanwix Hall Saloon. Poole clung to life for several weeks before succumbing to his injuries on March 8, 1855. While Morrissey was assumed to be the mastermind behind the attack, neither he nor Lew Baker was ever convicted of the murder.

Old Smoke returned to the boxing ring in 1858 to take on John C. Heenan, an enemy since childhood. Heenan was known as the "Benicia Boy," a nickname he derived from time spent in the California seaside town of Benicia. Heenan, like Morrissey, had been raised by Irish parents in Troy. Originally friends, the two immigrant families had engaged in a dispute following a cock fight. The dispute had ended bitterly, with the two families becoming foes. Following the example set by their parents, John Morrissey and John Heenan had developed a deep hatred for each other.

The Morrissey-Heenan prizefight was held on October 20, 1858, on a stretch of sand near Lake Erie in Canada, since prizefighting remained illegal on U.S. soil. Morrissey worked feverishly to obtain peak condition, and sources reported that he was in the best shape of his life. Similar to the "Rocky" character of the 1970s, Morrissey was reported to drink a daily cocktail of raw eggs and could often be seen training vigorously in the city streets.

Reports heralding the upcoming fight dominated the press. For months in advance, the match was the subject of numerous articles and conversations, some of which deemed the match the "fight of the century." Press coverage "exceeded anything ever witnessed" for a sporting event, and a new record for wagering was estimated to be at least $250,000.[8] Despite both opponents being bloodied through eleven grueling rounds, Morrissey emerged as the victor and retained his U.S. title. At the request of his wife, the lovely and educated Susie Smith, John Morrissey then exited the sport of prizefighting.

Settled into an early retirement, Morrissey turned his attention toward his growing New York gambling business and fostering his political career. He became active in Democratic politics and was highly connected with Tammany Hall as the leader of a gang called the Dead Rabbits. Due to their strong political ties, the Dead Rabbits were allowed to operate various gambling houses throughout the city without intrusion from police. Morrissey opened his first New York gaming house at Great Jones Street

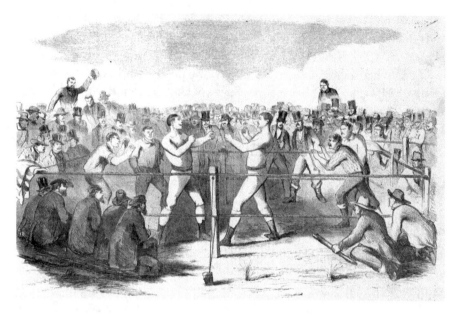

Sketch depicting the fight between John Morrissey and the "Benicia Boy." *Courtesy of the Library of Congress.*

and Broadway in 1859, which was followed by a second location at 12 Ann Street. Within a few years, he had become the proprietor of several resort-like gaming houses in the area, with interests in sixteen casinos at one point in time. Many of these establishments drew a following of celebrities, including socialites, writers, artists and politicians. Business was booming, and profits were huge. But John Morrissey had an even bigger dream, and for that, he would need horses.

Chapter 4

A WORLD-CLASS
RACECOURSE

John Morrissey arrived at Saratoga armed with a barrage of roulette wheels, faro cards and, according to author/historian Hugh Bradley, "suave dealers and strong-armed attendants."[9] A gambler to the core, Morrissey's idea was to develop a casino of such splendor that it "would rival those at Monte Carlo" and draw thousands of deep-pocketed travelers.[10] Folks wanted respite from the war, to drown their sorrows in gambling and gaiety, and Morrissey's casino would offer just that. As gambling was primarily a nighttime activity, Morrissey came up with a plan to entertain wealthy patrons during the daylight hours. John Morrissey—pugilist, former thug and gambling aficionado—would establish a world-class thoroughbred track.

Given Morrissey's background, he may have seemed an odd choice to start a racetrack that would cater to the rich and famous. But Morrissey, despite his flaws, was smart and determined. His boxing fame and political ties earned him access to the highest social circles. In 1860, for example, Morrissey and his wife, Susie, attended a ball honoring the newly elected President Abraham Lincoln and were presented to the president-elect. Despite such brushes with fame, however, Morrissey himself was not accepted by the social elite.

Fortunately for Morrissey, he had friends, as the saying goes, "in high places." Old Smoke had used his gambling profits to dabble in the stock market,

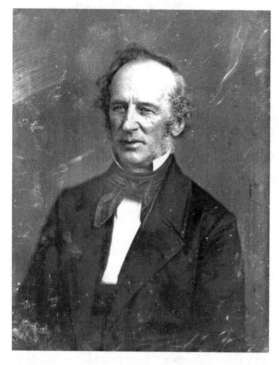

where he met shipping and railroad tycoon Cornelius "Commodore" Vanderbilt. The two men, both self-made, shared a passion for gambling, women and horses. Vanderbilt was in need of a "political agent" as he established the Harlem Railroad, and Morrissey, armed with his Tammany Hall connections, was a formidable ally. Through this association with Vanderbilt, Morrissey became acquainted with the Commodore's railroad business partner, Leonard Jerome, and well-heeled attorney and stockbroker William R. Travers. Jerome, a New York entrepreneur, had been dubbed by many as the "King of Wall Street." Travers, for his part, was reportedly a member of twenty-seven private clubs and would be described by the *New York Times* as "perhaps the most popular

Left, top: Railroad tycoon Cornelius "Commodore" Vanderbilt. *Courtesy of the Library of Congress.*

Left, bottom: William R. Travers, the namesake behind the Travers Stakes. *Courtesy of the National Museum of Racing and Hall of Fame.*

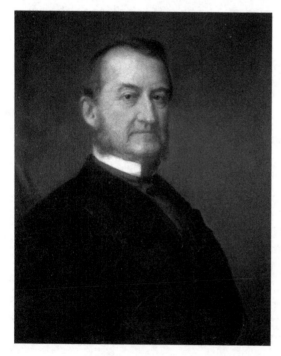

man in the city among Wall Street bankers and brokers, up-town club men, patrons and followers of the turf."[11]

Vanderbilt, Jerome and Travers were no strangers to high society; as such, they provided the social backing that Morrissey would need to bring his racecourse dream to fruition. The three men, along with another wealthy associate, John R. Hunter, were also well respected in horse racing circles. Travers maintained a New York–based racing stable and stud farm, Annieswood, which he owned in partnership with Hunter and George Osgood, a son-in-law of Commodore Vanderbilt. Unlike Morrissey, these men were accepted in Saratoga Springs' prominent social circles.

In association with his newfound friends, Morrissey set out to launch elite thoroughbred racing at Saratoga. Just one month after the Battle of Gettysburg commenced, Morrissey staged the first race meet. A three-day meeting had originally been announced in the *Spirit of the Times*; however, based upon the positive response, Old Smoke chose to extend the meet to four days. A subsequent posting in the *Daily Saratogian* announced "Running Races! At Saratoga" to be held from August 3 through 6, 1863, with two races each day, the first of which would begin at 11:30 a.m. Several of the races would be held in the heat format that was popular at that time, with "dashes" of one and a half or two miles also taking place. Daily admission was one dollar. According to sources, Morrissey himself donated much of the funding required for the inaugural meet. While Travers would be named the Saratoga Association's first president, Morrissey remained the controlling force behind the track operations, and all decisions were made through him.

Shortly after the *Spirit of the Times* heralded the opening meet, Saratoga's lavish hotels were filled to capacity. The streets bustled with well-dressed gentlemen and ladies sporting their finest silks. Folks arrived from as far away as Kentucky, Illinois, Missouri and Ohio; among them was John Clay, son of Kentucky statesman Henry Clay. Prized horses arrived by rail car and were ridden past the piazzas by their jockeys, many of whom were young African American slaves. Morrissey hired Dr. Robert Underwood, a prominent veterinarian and bookmaker, to manage the betting pools. While the pools were technically open to anyone, they were set in an auction format, and their cost limited betting to those with plenty of cash to spare.[12] For the occasion, John Morrissey purchased a horse, Jerome Edgar, from John Clay for the sum of $3,000. He renamed the horse after his friend John B. Davidson.

Saratoga's inaugural meet began on Monday, August 3, with a crowd of more than three thousand in attendance. The opening race was a winner-take-all sweepstakes, a series of one-mile heats open to three-year-old colts and

fillies. The entry fee was $200, and the race was closed at eight entries. By post time, however, six of the eight horses had scratched. Few wanted to face the two entries that the *Times* had characterized as "exceedingly great": a dark bay filly called Lizzie W. and a bay colt by the name of Captain Moore. The *Times* had further commented, "The colt has all along been held the best of the year, and is, beyond doubt, a strong, game and very fleet horse. The filly is so good that many thought, good as the colt was, she could clip him."[13]

As was expected, Captain Moore won the first heat, piloted by jockey Billy Burgoyne, who was riding despite nursing a broken leg. After a twenty-minute break, the second heat commenced. While Captain Moore set the pace, Lizzie W. and her jockey (known simply as "Sewell, the one-eyed black boy") came back to win the second heat by a neck. Tensions mounted as it came down to the third, and final, heat. Captain Moore was sent off as the favorite but was bested by the filly in the final stretch. With the win, Lizzie W. earned a place in history as the first horse to cross the wire at the "official" Saratoga Race Course.

Boosted by the victories of Lizzie W. and another filly called Sympathy, Saratoga's inaugural race meet was a social and financial success. There were, however, a few drawbacks. Folks grumbled that the track (formerly used for trotters) was too narrow and was not fenced in, and portions of the land were "covered by piny growths."[14] The track also measured slightly short of a mile. Additionally, the grandstand was small, forcing many of the race-goers to watch from their carriages.

Morrissey, eager to earn social approval, responded quickly to such complaints. In late August 1863, along with Travers and Jerome, he formed the Saratoga Racing Association, which would facilitate enhancements to the track. Travers was named as president and Jerome as vice-president, with Morrissey's friend Charles Wheatly serving as secretary. Other key appointees included John Hunter, George Osgood, wine dealer John Purdy, U.S. Hotel owner James Marvin and Morrissey's friend John Davidson. Morrissey himself would oversee the track's operations.

Morrissey led the association in raising funds to purchase a 125-acre plot located across the road, at a fee of $100 per acre. The association constructed a new course on this land and, according to the *New York Times*, "invested additional money in beautifying the surroundings."[15] The original site, later known as Horse Haven, would be utilized for morning workouts.

The first meet at the new location commenced on August 12, 1864, as the Civil War raged on. This marked the inaugural running of the Travers Stakes (known informally as "the Travers"), named for the association's first

president. The Travers was the first major stakes race in the United States and the second oldest in North America; only one race, the Queen's Plate at Woodbine in Canada, preceded the Travers Stakes. Originally set at 1¾ miles, the distance of the Travers would be altered over the years. The race would come to be known as "the midsummer Derby," owing to its timing and its reputation for drawing the top three-year-olds in the country.

DISTANCE OF THE TRAVERS STAKES

Year(s)	Distance
1864 to 1889	1¾ miles
1890 to 1892	1½ miles
1893, 1894, 1897 and 1904 to present	1¼ miles
1895 and 1901 to 1903	1⅛ miles

Perhaps fittingly, the inaugural winner of the first Travers Stakes was the entry of William Travers himself. Kentucky, a bay colt owned by Travers in conjunction with John Hunter and George Osgood, was a son of the celebrated stallion Lexington. Noted for the absence of his main rival, Norfolk (who had been banned from racing due to a gambling incident involving his owners), Kentucky's victory would be part of a twenty-race streak. Kentucky would also win the first two runnings of the Saratoga Cup, set at a distance of 2¼ miles, in 1865 and 1866. In its heyday, the Saratoga Cup was known as "the premier race on the programme," as it showcased the leading horses of the day and often attracted larger crowds than the Travers.

Even in the earliest years of the racecourse, summer rain was a frequent and unwelcome visitor. On occasion, races were postponed due to heavy rain. August rainstorms, often accompanied by thunder, would remain a cornerstone of Saratoga racing throughout the years, and horses that handled a wet or muddy track were often the betting favorites.

On March 11, 1865, the renamed Saratoga Association for the Improvement of the Breed of Horses was incorporated under the laws of the state of New York. While John Morrissey's name was absent from any formal documents, he remained the racetrack's controlling force and continued to oversee improvements to the facility. Among these were the fencing in of the track area and a lengthening of the grandstand by 120 feet. A steeplechase course was also created around this time, and steeplechase

Kentucky, winner of the inaugural Travers Stakes and the first two runnings of the Saratoga Cup. *Courtesy of the Library of Congress.*

races remained popular crowd-pleasers. One of the favored steeplechasers of the era was the dark bay colt Oysterman.

John Morrissey expanded his gambling operations in 1867 with the creation of the Saratoga Club House, the most elaborate casino in the United States. The cost of its initial construction was estimated at $190,000. The Club House maintained a few rules: women were not allowed, locals were restricted and credit was not extended, even to the wealthiest of gamblers. Modeled after the lavish casino at Baden Baden, Germany, the three-story Club House offered every amenity, and frequent guests included Ulysses S. Grant, John Rockefeller and Mark Twain. Other patrons included Pennsylvania oil tycoon John W. Steele, better known as "Coal Oil Johnny," who was noted as "the first of the great Saratoga exhibitionists" due to his penchant for flaunting, and spending, large amounts of money.[16] With its opulent surroundings juxtaposed against reckless gambling, the Club House was candidly referred to as an "elegant hell."[17] John Morrissey, in keeping up with his patrons, sported a diamond valued at $5,000 and reportedly dropped large sums of money at the poker table. Old Smoke had reason to celebrate; his empire at Saratoga was thriving.

Chapter 5

EARLY YEARS

B y 1870, daily attendance at the racecourse frequently exceeded ten
thousand spectators, and the land value per acre had increased from
$100 to $300. In response to demand, new races such as the Flash and
the Alabama Stakes were added to the Saratoga meet. The Flash Stakes,
the oldest U.S. race for two-year-olds of either gender, was inaugurated in
1869, followed by the Alabama Stakes for three-year-old fillies, established
in 1872. The latter was named in honor of racing patron William Cottrell.
A modest sort, Cottrell balked at the idea of a race bearing his name; it
was thus agreed to name the race after Cottrell's home state of Alabama.
The inaugural winner of the Alabama Stakes was Woodbine, a chestnut filly
sired by the great Kentucky and owned by financier August Belmont Sr.

DISTANCE OF THE ALABAMA STAKES

YEAR(S)	DISTANCE
1872–1901, 1904, 1906–16	1 mile and 1 furlong
1901, 1902 and on the turf in 1903	$1^1/_{16}$ miles
1905	$1^5/_{16}$ miles
1917 to present	$1^1/_4$ miles

Days prior to Woodbine's victory, race-goers witnessed the great duel
of Harry Bassett and Longfellow in the Saratoga Cup on July 16, 1872.

Currier & Ives portrait of the great Longfellow. *Courtesy of the Library of Congress.*

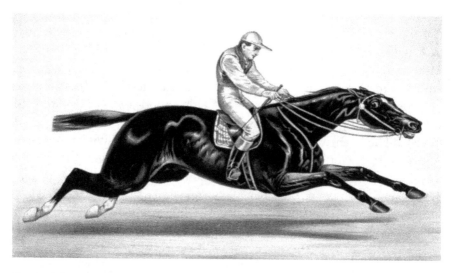

Currier & Ives portrait of Harry Bassett, winner of the 1871 Travers Stakes. *Courtesy of the Library of Congress.*

Longfellow, known as the "king of the turf," was the most popular horse in the United States at that time. Sired by the great Leamington, he was bred, owned and trained by "Uncle" John Harper of Nantura Stock Farm in Kentucky. Harper was a simple man who lived in a small cottage despite having acquired a substantial amount of wealth in the horse-breeding business.

Early Years

Longfellow was a large colt and, as such, needed time to mature. His racing career essentially began in his four-year-old season, and he won thirteen of sixteen starts. Longfellow's victories had included a defeat of Kingfisher (the 1870 Belmont Stakes champion) in the Saratoga Cup, running the first mile in a record 1:39½. The following season witnessed Longfellow's rivalry with the three-year-old Harry Bassett, winner of the 1871 Travers Stakes.

When Harry Bassett's owner, Colonel McDaniel, challenged Harper to a match race, the latter suggested that the two colts meet in the 1872 Monmouth Cup. McDaniel accepted. As Longfellow traveled by rail to the race, a sign was posted on his car that read, "Longfellow on his way to Long Branch to meet his friend Harry Bassett." The event had in fact become a match race, as the ten other entries quickly dropped out. It was Longfellow's race to lose, as Harry Bassett "stopped racing after a mile and a half" and Longfellow cantered to a win by one hundred yards.[18] The *New York Times* proclaimed the match "the sensational race of the year, and one about which the old school of horsemen have not stopped talking."

The two horses met again at the Saratoga Cup, set at two and a quarter miles. At the start of the race, however, Longfellow overreached, catching and twisting the shoe on his left front hoof. Early in the race, the colt showed signs of a struggle, and the jockey went to the whip for the first time in the four-year-old colt's career. Despite his pain, Longfellow showed the heart of most great thoroughbreds. He rallied for eighteen furlongs, only to lose by one length to his rival, who had beaten the track record by two and a half seconds. Longfellow hobbled off the track, three-legged. The racing plate had twisted so much that it had become embedded in the frog of his foot. That day at Saratoga was to be the great Longfellow's final race. He did, however, become a worthy sire; his progeny would include the champion filly Thora, winner of the 1881 Alabama Stakes and the 1882 Saratoga Cup.

As racing at Saratoga continued to flourish, John Morrissey turned his attention to politics. His Tammany Hall connections had led him to serve two terms in the U.S. House of Representatives, and he subsequently gained a seat in the New York State Senate in 1875. Yet Morrissey's years of hard living, which included smoking a reported seventeen cigars per day, had taken their toll on his physical health, and he suffered from a variety of ailments. In 1878, at the age of forty-seven, he reportedly suffered a stroke that resulted in paralysis of his right arm. He subsequently contracted pneumonia and died on May 1 of that year, reportedly with a Catholic priest by his side to administer last rites.

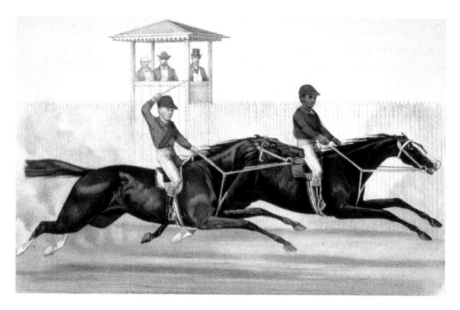

The duel between Harry Bassett and Longfellow in the Saratoga Cup. *Courtesy of the Library of Congress.*

An estimated twenty thousand mourners braved cold rain to attend Morrissey's burial in Troy. On the day of his funeral, all state offices were closed and flags were flown at half-mast. The *Times* wrote, "No burial ever evoked so many expressions of sorrow from the mass of people—the hard, rough workingmen and women…They turned out en masse today, in their working clothes and with the grit upon their faces, to watch with a tear in their eyes the passage of the funeral procession."[19] Old Smoke had perhaps best eulogized himself when he had proclaimed, "I am a gambler and a prize fighter; but no man can ever say that I turned a dishonest card or struck a low blow."[20]

Following Morrissey's death, the track continued to operate as usual. Charles Reed and Albert Spencer, professional gamblers and longtime friends of Old Smoke, stepped in to fill the void. Reed, a noted horseman, leased the racetrack, while Spencer took control of the betting pools and the Club House casino. Reed's Meadow Brook Farm would later include, among others, the stallion St. Blaise, winner of the 1883 Epsom Derby and the leading U.S. sire in 1890. (Reed would purchase the horse at a bid of $100,000 after the death of August Belmont Sr. in 1890.)

Under Reed's control, the racecourse continued to attract large crowds as it showcased some of the world's best horses. Parole, a son of Leamington

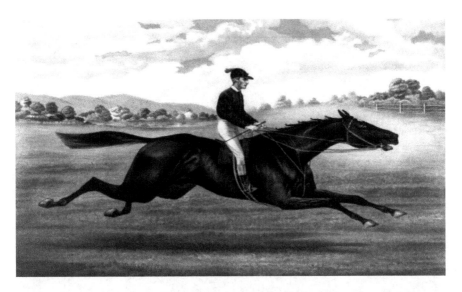

Currier & Ives portrait of Parole, two-time winner of the Saratoga Cup. *Courtesy of the Library of Congress.*

who was considered the greatest gelding of the era, won consecutive runnings of the Saratoga Cup in 1877 and 1878. The *Times* heralded his 1878 victory with a headline that read, "Parole wins the prize easily."[21] The *Times* further commented on the popularity of the race, noting, "The race for the Saratoga Cup has always succeeded in drawing a vast crowd, and this year has been no exception to the rule. The morning trains from Albany and Troy were heavily laden with turf-men from New York, who always make it a point to be in Saratoga on this particular day." Another key winner during this time was Duke of Magenta, one of the last sons of the great Lexington. Duke of Magenta's victories at Saratoga included the 1877 Flash Stakes as well as the Kenner Stakes and the Travers in 1878.

In 1881, the Spinaway Stakes for two-year-old fillies was run for the first time, contested at a distance of five furlongs. The bay filly Memento, owned by George Lorillard, was victorious in the inaugural running, piloted by jockey Tom Costello. That same season, Kentucky Derby winner Hindoo arrived at the Spa and captured the Travers Stakes, Sequel Stakes, the United States Hotel Stakes and the Kenner Stakes as part of an eighteen-race winning streak. He covered the two-mile Kenner in 3:32, besting the previous speed record by a full 3 seconds. Of the latter victory, the *Times* wrote, "This year the Kenner may be said to have been a walk-over, or a mere exhibition of the powers of that great colt Hindoo."[22]

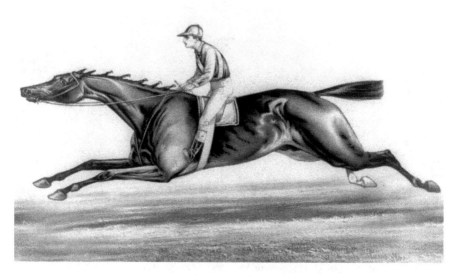

Currier & Ives portrait of Hindoo, winner of multiple stakes races at Saratoga. *Courtesy of the Library of Congress.*

The racecourse continued to prosper during this time, and gamblers wagered large amounts of money on the races. One such person, John Warne "Bet-a-Million" Gates, won so much cash that he was forced to borrow a "large market basket" to carry it.[23] Gates, one of the founders of the Texas Oil Company (which later became Texaco), was known for his compulsive spending habits. In addition to gamblers, ladies frequented the racecourse. The *Times* wrote in 1881 that "fully one-third of the many spectators of the races to-day were ladies, and their magnificent costumes made the grand stand a brilliant scene."[24]

As the decade wore on, however, the order of operations was slowly beginning to unravel. Attendance rates began to decline at the Spa as it competed with Monmouth Park in New Jersey, which offered larger purses and thus attracted the higher-caliber horses. Like his predecessor John Morrissey, Charles Reed longed for acceptance in Saratoga's prominent social circles despite a less-than-elite background. In fact, Reed had once killed a man in New Orleans and had received a death sentence but was pardoned by a lawman who was sympathetic to gamblers. At this time, however, Saratoga was the subject of frequent anti-gambling crusades, and Reed apparently had enough. He sold his share of the track to Spencer and returned to New York City. Spencer continued to operate

the track, along with the Club House casino, and served as secretary and treasurer of the Saratoga Association.

Anti-gambling sentiments led by Wall Street financier Spencer Trask continued to pervade the track. Trask was so intent on removing gambling from the area that he personally hired a group of New York detectives (reportedly at a cost of $50,000) to gather evidence against Spencer. In 1890, Spencer opted to sell the racetrack for the sum of $375,000. As no potential purchasers were in sight, management began to falter, and several members of the Saratoga Association, including original secretary Charles Wheatly, resigned from their positions.

While Spencer struggled to find a buyer, an unsavory character by the name of Gottfried Walbaum (better known as "Dutch Fred") arrived on the scene. Walbaum, whose reputation and business sense were less than stellar, had purchased the Guttenberg racetrack in New Jersey and operated it in a shady manner. His motto at the track, which was often overheard, was, "Nobody can beat me. I'm just a sucker for luck." He welcomed the idea of adding another racetrack to his fortune. Therefore, while profits surged at the Guttenberg site, Walbaum acquired a 90 percent share in the Saratoga Race Course for the asking price of $375,000 in 1891. Interestingly, that same year he was indicted for unlawful activity (or, as the *Times* reported, "keeping a disorderly house") at the Guttenberg track.[25]

Walbaum's presence set off a chain of negative events at Saratoga. As he routinely gambled all night and slept until noon, Walbaum changed the starting times of the day's races from 11:30 a.m. to 2:30 p.m., leading to a marked decline in attendance at local hotels while angering Saratoga's bookmakers. He also implemented betting rooms that were open to women and to children as young as ten years old. Walbaum's constant arguments with staff and bookmakers were frequently alluded to in the news. Nevertheless, the track profited as his cohorts and backers attended the races in full force. Walbaum solidified his control of the track when he became president of the Saratoga Association in 1892.

In time, the negative consequences of Walbaum's actions became readily apparent. Many trainers who had been fixtures at the track relocated their horses and left town. Beginning in 1892, several key races (including the Saratoga Cup, the Alabama Stakes and the Spinaway Stakes) were not held due to a lack of championship-caliber horses and management problems at the track brought on by Walbaum. In 1894, the *Times* wrote, "Walbaum is getting himself generally disliked by

his dictatorial acts here, but he prefers to defy public opinion."[26] *Life* magazine concurred. The magazine wrote of the Walbaum era, "Under his management, the crooks took over and racing became so dishonest at Saratoga that the better stables would not race there."[27] For the sake of the racecourse, something would have to change.

Chapter 6

A NEW BEGINNING

While the racetrack (known as "the Spa" due to its proximity to the mineral springs) had fallen on hard times, Saratoga's gambling houses continued to thrive. The Club House, which had continued operations in the years since Morrissey's death, was purchased in 1894 by gambling entrepreneur Richard Canfield. Several renovations were made to the casino at this time, including the addition of an elaborate dining room and various fixtures and adornments. Canfield also purchased the adjacent property and created a formal Italian garden in what is now Congress Park. An honest man with superb tastes in dining and art, Canfield was well respected in social circles. Under his ownership, the casino prospered, and men of influence continued to arrive on the scene.

One of the most influential figures at Saratoga during this time was William Collins Whitney, whose professional titles included secretary of the navy, attorney and financier. Whitney was also a major player in the horse racing industry, breeding champion thoroughbreds at his Long Island–based Westbury Stable. Whitney's stallion band included the 1898 Horse of the Year Hamburg, whom he had purchased for the sum of $60,000 in 1900. Whitney's breeding operation would ultimately produce twenty-six American stakes winners, including the champion fillies Artful and Tanya.

An affable and generous man, Whitney was recognized as one of Saratoga's proverbial "big spenders." According to *Life* magazine, "One day, just to be nice, [Whitney] called in a betting commissioner and explained that he wanted to bet $100 on his horse, Goldsmith, for each of the many guests he

William C. Whitney was a key influence on the history of the racecourse. *Courtesy of the Library of Congress.*

had brought with him to Saratoga—and $100 as well for each of the maids, waiters, clerks and bartenders who had served his party during its stay. The bet came to $12,000 and, when Goldsmith won at 6-to-1, Whitney became the most toasted host in Saratoga." Later, when his horse, Volodyovski (whom he had leased from London socialite Lady Valerie Meux), won England's prestigious Epsom Derby in 1901, Whitney allegedly purchased champagne for everyone in attendance at the Saratoga races.

Whitney's generosity and business sense proved an ample remedy for the ailing racetrack. Around the turn of the century, he led a syndicate of wealthy horsemen to purchase the track and bring it back to its former glory. As a need for additional stables and training facilities became clear, the association purchased more than one hundred acres of land situated just north of Horse Haven. A new one-mile oval track was created, and the old track, known as the "Oklahoma," was utilized for morning workouts.

Under this new regime, various improvements were made over the next few years. The track was eventually lengthened to a mile and an

eighth and a course was constructed specifically for racing on turf. A new paddock, used for saddling horses, was also created. The grandstand was shifted so that it faced away from the sun, providing additional comfort for spectators on the hot summer race days. Improvements to the track's clubhouse included the addition of an iron railing with ornamental gates and the establishment of a lower-level café.

Dissatisfied with the culinary offerings at the track, Whitney also hired a new caterer, Harry M. Stevens, to serve the wealthy Spa patrons. While Saratoga was the first racetrack to be catered by Stevens, his fame would one day reach legendary proportions. Decades later, Stevens's company would become the official concessionaire of the Kentucky Derby, unveiling the official souvenir mint julep glass in 1945. Stevens would also be credited with introducing the hot dog at baseball parks nationwide.

With Stevens's catering company on site, the racetrack became the center of social activity in Saratoga Springs. A lasting tradition began whereby patrons ate breakfast at the track kitchen while watching the morning workouts under Saratoga's legendary morning mist. Occasionally, a patron, weary from champagne and late-night gambling, would pass out in the

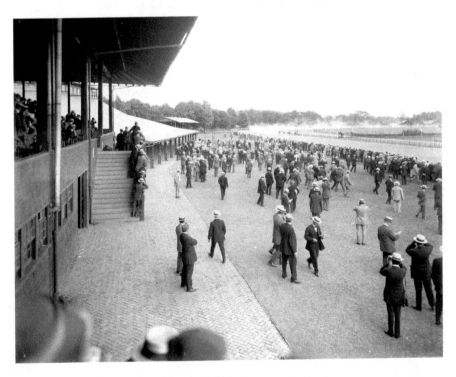

The track in 1900. *Courtesy of the Library of Congress.*

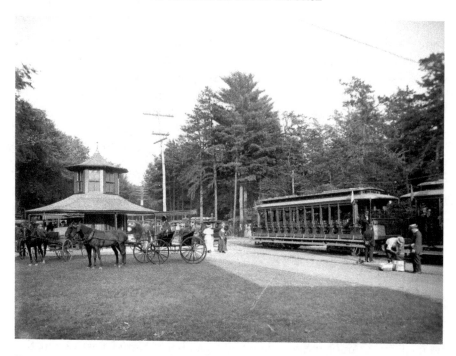

Entrance to the racecourse in the early 1900s. *Courtesy of the Library of Congress.*

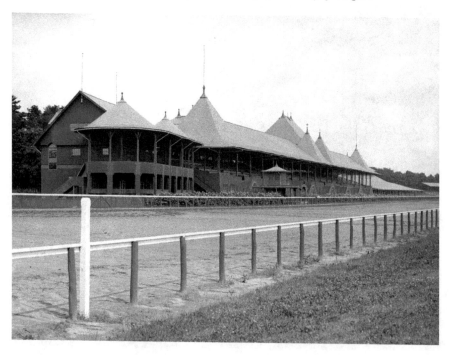

View of the track and grandstand in 1906. *Courtesy of the Library of Congress.*

dining area; during these instances, the lead waiter would "discreetly put up a screen" and continue serving the other guests.[28]

One of the largest appetites at the Spa's breakfast table undoubtedly belonged to James Buchanan ("Diamond Jim") Brady. A self-made millionaire, Brady had a penchant for expensive diamonds and an equally strong passion for food. According to sources, Brady often ate enough for several people at a single sitting and washed down each meal with an enormous box of candy. Brady's frequent companion at the racecourse was the voluptuous Lillian Russell, a well-known actress and singer who rode around the grounds on a gold-plated bicycle. Rumor has it that Russell's appetite nearly matched that of Brady.

While guests dined on delicacies such as frog legs and champagne, the racecourse continued to showcase a bevy of great thoroughbreds. Races that had been curtailed during the Walbaum era were reinstated, and new stakes races were introduced. The Saratoga Handicap, a one-and-a-quarter-mile race for horses three years old and up, was instituted in 1901, along with the six-and-a-half-furlong Saratoga Special Stakes for two-year-olds. Another key addition was the Hopeful Stakes ("the Hopeful") for two-year-old colts and fillies, which originated in 1903 as a showcase for the most promising juveniles on the East Coast. The name of the race was derived from every owner's

"Diamond Jim" Brady (right) was a frequent visitor to Saratoga. *Courtesy of the Library of Congress.*

Actress and singer Lillian Russell often accompanied Jim Brady to the track. *Courtesy of the Library of Congress.*

hope that his or her young horse will emerge as a great champion. The inaugural winner of the Hopeful was Delhi, a colt by 1896 Kentucky Derby winner Ben Brush out of the mare Veva. Delhi would go on to win the Belmont Stakes the following year.

The second running of the Hopeful Stakes was won by William Whitney's homebred filly, Tanya, who aptly defeated several colts to capture the Hopeful crown. Tanya also won the Spinaway Stakes that same year, running both races under the stable colors of businessman Herman Duryea. Upon Whitney's death in 1904, the filly had been leased to Duryea, along with several other horses. Following these two victories at Saratoga, Tanya was purchased by Whitney's eldest son, Harry Payne Whitney. Donning the Whitney stable colors in 1905, Tanya became the second filly in history to win the Belmont Stakes.

It was around this time that America found itself on the brink of reform, and many casinos and racetracks were forced to close. In 1907, Richard Canfield shuttered the doors to his famous casino. It was sold to the town in 1911 and would be preserved as a historic landmark. The former Canfield Casino now serves as the headquarters of the Saratoga Springs History Museum. The wave of reform extended to the racetrack in 1911, when state legislation outlawed wagering on horse races. Two years later, when a New York court ruled that oral betting was in fact legal, the racecourse reopened and key races were resumed.

A New Beginning

Tanya, winner of the 1904 Hopeful Stakes. *Illustration by Allison Pareis.*

As bookmakers returned by rail to the Spa, a brass band cranked out a series of celebratory tunes. By 1913, activity had resumed at the track, which was now operating in all its splendor.

Despite the death of its patriarch in 1904, the Whitney family's prominence at Saratoga remained in full force. In 1914, Harry Payne Whitney made history when his filly, Regret, became the first horse to win the Hopeful, the Saratoga Special and the Sanford Stakes. The latter was named for Stephen and John Sanford, members of one of Saratoga's original horse racing families. Only three other horses would match Regret's great feat: Campfire in 1916, Dehere in 1993 and City Zip in 2000. Regret would earn a permanent place in racing history the following season when she became the first filly to win the Kentucky Derby.

While Regret was racing into the record books, a lanky bay gelding was also making a name for himself at Saratoga. His name was Roamer, and his very existence was the stuff of legends. The aptly named foal was produced when a teaser stallion called Knight Errant allegedly jumped a fence and bred a blind claiming mare named Rose Tree II. Expectations were low for the resulting foal, who was quickly gelded and began his career in a $1,000 claiming race for the Clay brothers of Kentucky. When the horse was promptly claimed, the brothers realized their error in judgment and purchased the gelding back for $2,005.

A view of a race in 1913. *Courtesy of the Library of Congress.*

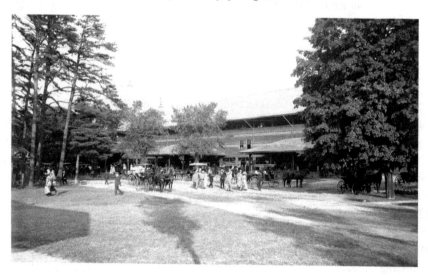

The entrance to the racecourse in 1915. *Courtesy of the Library of Congress.*

Roamer would be subsequently sold to Andrew Miller, a New York–based publisher (and later founder of *Life* magazine), for the sum of $2,500. Miller, the secretary and treasurer at the racecourse, had been part of the syndicate led by William Whitney that had purchased the track back in 1900. The Harvard-educated Miller had a good eye for racing talent. He

Right: Harry Payne Whitney, eldest son of William C. Whitney, owned several champion thoroughbreds. *Courtesy of the Library of Congress.*

Below: Regret, winner of the Sanford, Hopeful and Saratoga Special in 1914, shown here with jockey Joe Notter. *Courtesy of the Keeneland Library.*

Roamer, winner of multiple stakes races at Saratoga, shown here with jockey Thomas McTaggart. *Courtesy of the Library of Congress.*

placed Roamer in the capable hands of trainer A.J. "Jack" Goldsbrough, who would guide the horse into the winner's circle on countless occasions. Roamer's victories at the Spa included the Saratoga Special Stakes in 1913, the Saratoga Cup in 1915 and the Saratoga Handicap, which he won three times, in 1915, 1917 and 1919. He romped in the 1914 Travers, winning the race by ten lengths and setting a new track record in the process. He captured Horse of the Year honors that same year and was named champion older male the following two years. In a career spanning seven years, Roamer raced ninety-eight times, logging thirty-nine wins, twenty-six places and nine shows. He set numerous records, ran well on all surfaces and carried weights of up to 133 pounds. Sadly, Roamer passed away at the age of nine as a result of a paddock accident, only hours after the death of Andrew Miller.

As the new decade approached, Saratoga's annual yearling sale was introduced in 1917. The origins of the sale could be traced back to 1898, when horsemen William B. Fasig and Edward A. Tipton established a business for selling high-quality horses at auction. The new company, originally based at Madison Square Garden, specialized in selling racing stock thoroughbreds and trotters; high-class road hacks and carriage horses were also offered.

A New Beginning

When William Fasig died in 1903, Tipton hired his office assistant, Enoch James Tranter, as a replacement. Tranter, a former stable boy, was gifted with both business sense and a keen eye for thoroughbreds. In 1917, he partnered with several Kentucky thoroughbred breeders to develop an annual auction of select thoroughbred yearlings. It was decided that the event should be held at the high point of the racing season—Saratoga's annual summer meet.

Bids were relatively low at the inaugural sale. Within one year, however, prices—and clientele—had increased dramatically. *Life* magazine reported, "As the prices became fancier so did the bidders. The young horses they spent fortunes for arrived in town by train and one of Saratoga's sights was watching them being led, kicking and squealing, up circular Street and out Union Avenue to the track. Every year, a few would get loose and everybody would join in the chase."[29] It was the dawn of a new and lasting tradition at Saratoga.

Chapter 7

"THE MOSTEST HOSS"

August Belmont Jr. knew a good horse when he saw one. Belmont had been born into a horse racing family; his father, August Sr., was the namesake behind the Belmont Stakes, which was originally raced at New York's Jerome Park. When the elder Belmont died, August Jr. inherited the family's breeding farm, Nursery Stud, based in Babylon, New York. August Jr. relocated the farm's primary operations to Kentucky, where it became one of the central breeding farms in the racing industry. The farm's stallion roster included, among others, the homebred Fair Play, a son of the temperamental but immensely talented Hastings. The latter, armed with a volatile temperament, had been known to bite other horses while racing in close quarters.

In 1916, Belmont Jr. bred Fair Play to his mare Mahubah. She was the daughter of 1903 English triple crown champion Rock Sand, who had been purchased and imported by the younger Belmont in 1906 for the sum of £25,000. The resulting foal, born on March 29, 1917, was a large chestnut colt. Belmont, now in his sixties, was stationed in France in his role as a major in World War I. When it came time to name the foal, Mrs. Belmont (who always named the farm's horses) dubbed him "My Man o' War" as a tribute to her husband. The word "My" was subsequently dropped from the Jockey Club papers, and the horse was officially named "Man o' War."

Belmont had always been largely involved in the training of his horses, yet there was not much he could do while serving overseas. As such, he was prompted for the very first time to sell his crop of yearlings at the Saratoga auction. According to sources, this plan did not originally include Man o'

August Belmont Jr., breeder of Man o' War. *Courtesy of the Library of Congress.*

War; Belmont had intended to keep the best colt for himself. In the end, however, Belmont felt that it was not in his best interest to keep the colt, and Man o' War was shipped to Saratoga to be sold with the other Nursery Stud yearlings on August 17, 1918.

Louis Feustel was familiar with Nursery Stud, as he had worked as a young man for the Belmont stables. Feustel was now the trainer of horses for Samuel Riddle, a textile manufacturer and owner of Glen Riddle Farms in Pennsylvania. According to an interview with the trainer shortly before his death, Feustel had urged his boss to purchase the entire crop of Belmont yearlings the month prior to the Saratoga auction. Feustel especially liked the Mahubah colt, Man o' War. Riddle, however, was allegedly not impressed with the lanky chestnut and failed to act on Feustel's advice.

When the auction date arrived, Riddle attended, along with his wife, and purchased several of the Belmont colts. According to Feustel, Riddle purchased

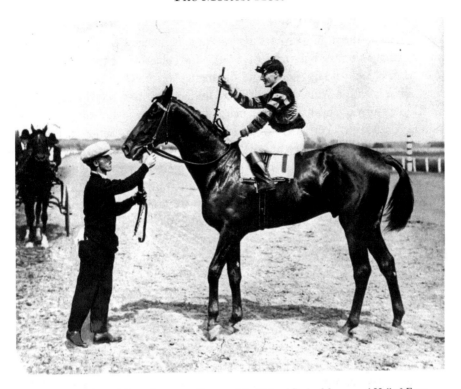

The immortal Man o' War at Saratoga. *Courtesy of the National Racing Museum and Hall of Fame.*

The U.S. Hotel in Saratoga, the namesake behind the U.S. Hotel Stakes. *Courtesy of the Library of Congress.*

Man o' War at the urging of Mrs. Riddle, at a price tag of $5,000. While this was far above the average price of $1,107 for colts sold at the auction that year, Man o' War did not command the highest price. That honor went to a chestnut colt with a white blaze named Golden Broom, who was purchased by Riddle's niece, Sarah Jeffords. Incidentally, the man who did the actual bidding on Man o' War was not Riddle himself, but his friend Ed Buehler. The latter's nephew, Richard Stone Reeves, would go on to become one of the most famous painters of thoroughbred horses in modern history.

Man o' War proved difficult to break and train but progressed under Feustel's patience and steady hand. The colt, nicknamed "Big Red," began his race career at Belmont Park, easily breaking his maiden in a six-length romp. In August, he arrived at Saratoga for the U.S. Hotel Stakes, coming off a one-month hiatus. The U.S. Hotel Stakes, first run in 1880, was originally open only to three-year-olds but was modified in 1895 to a race for younger horses. In 1901, the race was distinguished by the *New York Times* as a "rich" race because it offered a purse of $10,000.[30]

When Big Red arrived at the Spa, the colt was already being compared to great horses such as Colin (undefeated in fifteen starts, including the 1907 Saratoga Special and Grand Union Hotel Stakes) and Sysonby (whose only loss in fifteen starts was attributed to foul play). Man o' War impressed fans with his

Colin, winner of the Saratoga Special and Grand Union Hotel Stakes. *Illustration by Allison Pareis.*

apparent ease in carrying weights far greater than those of his rivals. Carrying 130 pounds in the U.S. Hotel Stakes, Big Red won by two lengths over Harry Payne Whitney's colt, Upset. By the time he ran in the six-furlong Sanford Stakes at Saratoga on August 13, Man o' War had amassed six straight wins.

Starting gates were not yet in use at that time in horse racing. Rather, a tape barrier was utilized as the race's starting point. The usual starter was not around that day, and a substitute was assigned to start the race. The substitute reportedly encountered difficulty assembling the horses at the tape; when the tape was sprung, Man o' War was backing up, and by the time he was able to turn himself around, the big colt was well behind the field. According to an article by the *Louisville Courier Post*, Man o' War was virtually "left at the post," which some believe was due to a riding error by jockey Johnny Loftus.

Despite this unfortunate start, Man o' War's powerful stride propelled him from that position to third as the field reached the home stretch. The horses, however, were tightly bunched together, and Man o' War was forced to the outside. Again he made up ground but was ultimately bested a half-length by the aptly named Upset, carrying fifteen pounds less than Man o' War. The highly priced Golden Broom finished third. While it was the most shocking defeat of a favorite to date, Saratoga had already begun to earn its reputation as the "graveyard of champions." Back in August 1914, the *Albany Times Union* had proclaimed in a headline: "Picking Winners at Saratoga Has Become a Difficult Task."[31] Incidentally, one of the earlier upsets noted by the *Times Union* was the victory of Man o' War's sire, Fair Play, in the 1907 Flash Stakes over Whitney-owned favorites Royal Tourist and Adriana.

Big Red next took to the Saratoga track for the six-furlong Grand Union Hotel Stakes ten days later. This race, inaugurated in 1865, had been named for the celebrated hotel that was a favorite of racecourse officials. Man o' War had an easy win over Upset this time, beating his rival by one full length and earning the purse of $10,000. He subsequently won the Hopeful Stakes by an impressive four lengths.

As a three-year-old, Man o' War returned to Saratoga in early August, where he won the Miller Stakes (formerly the Kenner Stakes but run in 1920 as the Miller Stakes in honor of Andrew Miller) by six lengths while being held under restraint by jockey Earl Sande. Man o' War received an audience befitting a king, drawing a crowd of nearly thirty-five thousand wildly cheering fans. The *New York Times* wrote, "Just as soon as the third race was over the crowd began to file out of the stands and swarm across the broad park where the horses are saddled for the next race…Motion picture camera men were present to capture every move the horse made during his preparation for the race."

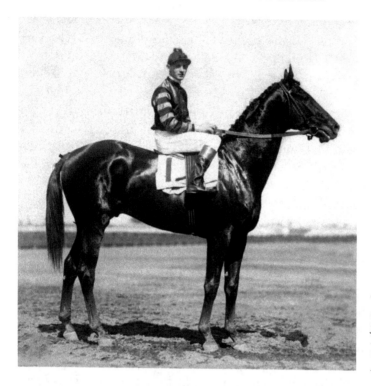

The great Man o' War with jockey Clarence Kummer. *Courtesy of the Keeneland Library.*

Big Red's final victory at Saratoga occurred in the Travers on August 21. Again he won handily, under restraint, equaling the track record of 2:01 ⅕ set earlier by Sir Barton in the Saratoga Handicap. Only two opponents dared to face the great Man o' War in the Travers—Upset and John P. Grier—and they finished behind him in that order. The annual Travers Cup would later become known as the Man o' War Trophy, having been donated by Mrs. Riddle in the great horse's honor. The track record would stand for another forty years, and Man o' War would go on to defeat Sir Barton, the first Triple Crown winner, in the Kenilworth Park Gold Cup in Windsor, Ontario.

At the time of his retirement after his three-year-old season, Man o' War had amassed twenty victories in twenty-one starts, set numerous track records and earned himself a place in history as perhaps the greatest racehorse of all time. Legendary racing writer and historian Joe Palmer would later note of Man o' War, "He did not beat, he merely annihilated. He did not run to world records, he galloped to them. He was so far superior to his contemporaries that they could not extend him. In 1920 he dominated racing as perhaps no athlete—not Tilden or Jones or Dempsey or Louis or Nurmi or Thorpe or any human athlete—had dominated his sport."[32] Perhaps the most fitting description of Man o' War was attributed to his longtime groom, Will Harbut, who dubbed him "the mostest hoss that ever was."

Chapter 8

THE ROARING
TWENTIES

In the year that followed Man o' War's final victory, Saratoga became the site of an infamous betting scandal. The situation involved mafia kingpin Arnold Rothstein, a frequent visitor to the track, who was known to drop $200,000 on a single bet. Rothstein was nicknamed "the milk drinking thug," as he often drank a glass of milk in lieu of whiskey or champagne. Rothstein had been the reported mastermind behind baseball's notorious "Black Sox" scandal, in which Chicago White Sox players were allegedly paid to lose the 1919 World Series.

Rothstein was a frequent visitor to the Spa and maintained a string of young horses. In 1921, he owned a three-year-old by the name of Sporting Blood, who had been entered in that year's Travers Stakes. At that time, horses could be entered up until noontime on race day. The favorite for the race was Harry Payne Whitney's filly, Prudery, winner of the Alabama Stakes. It is alleged that Rothstein paid someone close to the Whitney stable for information concerning the filly's condition. When it was revealed that the filly was not 100 percent sound, Rothstein allegedly conspired with trainer Sam Hildreth to enter the horse Grey Lag on the morning of the race in an effort to boost the betting odds. The plan was successful, and the odds on Sporting Blood increased to 3-1, at which point Rothstein coolly wagered $150,000 on his own horse.

Just prior to post time, Hildreth scratched Grey Lag from the race, leaving Prudery and Sporting Blood the only entrants. Prudery set off to an early

lead before being overtaken by Sporting Blood, who ultimately won the race by two lengths. Rothstein won over $500,000 with Sporting Blood's victory. The *Times* proclaimed the result "one of the biggest upsets of the racing season," noting that many in the crowd of twenty-five thousand spectators "couldn't shout, but merely gasped...Prudery's beaten."[33] While conspiracy allegations were made, they were never officially proven, and the story has become woven into the tapestry of Saratoga's dark history.

In 1922, the Test Stakes for three-year-old fillies was established at a distance of a mile and a quarter. The inaugural running was won by Emotion, who would go on to be named the season's leading three-year-old filly. The distance of the race was changed to seven furlongs for the second running (in 1926, after a three-year hiatus), which was won by Joseph E. Widener's bay filly Ruthenia.

Saratoga's races had by this time earned a reputation of true greatness. In June 1922, the *Times* issued a feature on the upcoming Spa season, proclaiming the Travers as "the real classic of the turf." The article further stated, "Of all the turf classics that grace this country's racing the Travers ranks with the best," and proclaimed, "Greater horses than some of those which have won the Travers and the Miller in the past have never trod American soil."[34] The *Times* also noted the fact that the Travers and the Alabama Stakes were instituted years prior to Churchill Downs's iconic Kentucky Derby and Oaks.

History continued to be made in 1922 when Exterminator won the last of his four successive Saratoga Cup races, en route to capturing Horse of the Year honors. The lanky gelding raced until the age of nine, winning fifty of ninety-nine starts, including the 1918 Kentucky Derby. Known by the nickname "Old Bones," Exterminator was a perennial favorite at Saratoga. The *New York Times* wrote in a special edition on August 8, "W.S. Kilmer's magnificent old gelding today performed a feat unique in American turf annals when he won the Saratoga Cup for the fourth year in succession. Grand stand and club house rose to cheer this gallant campaigner, veteran of many a thrilling battle for years past, when he was brought back to the judges' stand...Men and women joined in applauding Exterminator and the tumult was one of the greatest at the Spa this season."[35]

In addition to Exterminator, many other champions appeared at Saratoga throughout the aptly named Roaring Twenties. In 1921, Morvich swept the U.S. Hotel Stakes, Saratoga Special and Hopeful; the following spring, he would become the first California-bred to win the Kentucky Derby. Mad Play and Chance Play—sons of Fair Play—won the Saratoga Cup in 1925 and 1927, respectively. And Kentucky Derby winner Reigh Count galloped

The Roaring Twenties

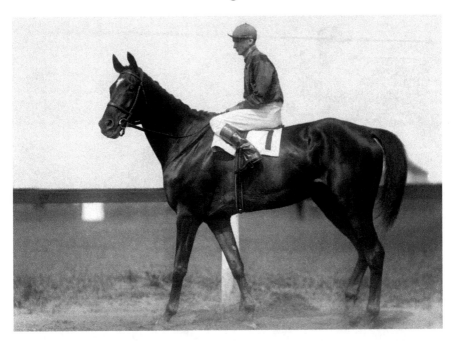

Exterminator, winner of four consecutive Saratoga Cup races, shown here with jockey Albert Johnson. *Courtesy of the Keeneland Library.*

to victory in both the Saratoga Cup and the Miller Stakes in 1928. Owner John Daniel Hertz (founder of Yellow Cab and eventually Hertz Rent-a-Car) turned down a million-dollar offer to purchase Reigh Count in 1929, jokingly stating that "a fellow who would pay $1,000,000 for a horse ought to have his head examined, and the fellow who turned it down must be absolutely unbalanced." Reigh Count would go on to sire, among others, 1943 Triple Crown winner Count Fleet.

In the same year that Reigh Count won the Saratoga Cup, the racecourse added a new member to its growing family of stakes races. The Whitney Handicap, named for the recently deceased William Payne ("Payne") Whitney, was established in 1928 as a race for horses three years of age and older; the race was originally closed to geldings. Payne Whitney was the founder of Greentree Stable and the younger brother of Harry Payne Whitney. The inaugural winner of the Whitney Handicap was the five-year-old mare Black Maria, who bested three other entries, including Belmont victor Chance Shot and Kentucky Derby champion Whiskery (the latter a Harry Payne Whitney homebred). It would be the final win of the mare's illustrious career, which also included victories in the Kentucky Oaks, Met Mile, Ladies Handicap and Aqueduct Handicap.

Black Maria, winner of the inaugural Whitney Handicap. *Illustration by Allison Pareis.*

DISTANCE OF THE WHITNEY HANDICAP*

YEAR(S)	DISTANCE
1928–54	1¼ miles
1955 to present	$1\frac{1}{8}$ miles

*Closed to geldings until 1971

As the decade wore on, the racetrack boomed with activity and excitement. The 1920s was a time of prosperity, and folks were not afraid to spend freely. Oil baron Harry Sinclair frequently bet sums of up to $100,000 on his horses, and comedian Joe E. Lewis performed shows for the patrons when the races were over. Boxers Gene Tunney and Jack Dempsey, in town for training, frequented the track, as did writer Damon Runyon, whose motto was, "All horse players die broke." Newspaper mogul Herbert Bayard Swope, who later became chairman of the New York State Racing Commission, was another frequent visitor. Folks arrived in fancy chain-driven Mercedes automobiles to play the races by day and gamble in the new casinos at night. It was just as John Morrissey had originally planned.

Chapter 9

THE FOX, THE BISCUIT AND
THE ADMIRAL

D espite the onset of the Great Depression in 1929, folks continued to attend, and bet on, the Saratoga races. While much of the country was riddled with financial worry, the Spa offered an idyllic getaway. In 1930, a new attendance record at the Travers was set, with thirty thousand spectators present for the midsummer derby. The crowd on hand to watch the race included Franklin Delano Roosevelt, then serving as governor of New York. In addition to setting a record for attendance, the 1930 Travers became the site of another of racing's most shocking upsets with the defeat of Triple Crown champion Gallant Fox. This defeat solidified Saratoga's reputation as the "graveyard of champions."

Gallant Fox was a tall, leggy bay colt with a white blaze and a distinctive "wall eye" (in which the iris appeared whitish-gray rather than brown). Known affectionately as the "Fox of Belair," the colt was a sociable animal that enjoyed the company of other horses and showed affection toward his handlers. He was owned and bred by William Woodward Sr. of New York's Belair Stud and trained by future Hall of Famer "Sunny" Jim Fitzsimmons.

The Fox of Belair had a mediocre two-year-old campaign but did manage two wins, which included Saratoga's Flash Stakes, a highly touted five-furlong juvenile sprint. Inaugurated in 1889, the Flash was the longest-running U.S. race for two-year-olds of either gender. Gallant Fox's other win that season was in the Junior Champion Stakes at Aqueduct. It was in the following season, however, that he truly blossomed. Jockey Earle Sande, who had

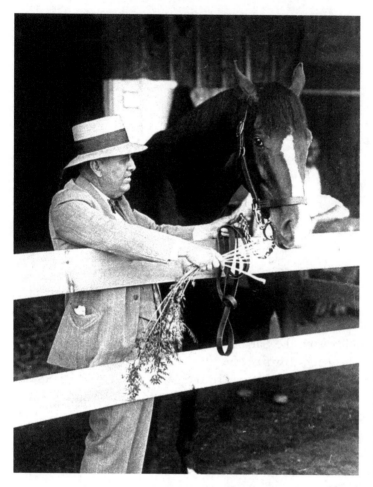

Triple Crown champion Gallant Fox at Saratoga with trainer "Sunny" Jim Fitzsimmons. *Courtesy of the Library of Congress.*

retired two years prior, returned to riding specifically to take the mount on the leggy bay. Sande was likely also motivated by financial reasons, as he had lost a substantial amount of money in the 1929 crash of the stock market.

While another horse, Sir Barton, had won the Kentucky Derby, Preakness Stakes and Belmont Stakes in 1919, it was Gallant Fox's sweep of the three races that resulted in the first reference to the "Triple Crown." The *New York Times* was credited with the origin of the term following Gallant Fox's victory in the 1930 Kentucky Derby, which at that time was held after the Preakness Stakes.

Gallant Fox arrived at Saratoga in 1930 as the 1-2 favorite for the Travers Stakes, fresh from a string of victories that included the aforementioned Triple Crown. The Travers was heralded as a battle between Gallant Fox and Harry Payne Whitney's Whichone, who had won the 1930 Whitney

The Fox, the Biscuit and the Admiral

Handicap while racing against older horses. Over a muddy track following a deluge of Saratoga rain, the two colts entered into an immediate speed duel. Whichone, ridden by Sonny Workman, was positioned in the middle of the track, with Gallant Fox remaining equally far from the rail. As the two horses jockeyed for position, a 100-1 long shot by the name of Jim Dandy sped past the pair, ultimately winning the race by eight lengths over a tired Gallant Fox. Whichone suffered a career-ending injury in the stretch and finished another six lengths back. Jim Dandy, who had also won the Grand Hotel Stakes at Saratoga as a two-year-old, is forever remembered for his unexpected Travers victory. In fact, the Jim Dandy Handicap, inaugurated in 1964, has become a major prep race for the modern-day Travers.

Gallant Fox returned to the Saratoga track for the mile-and-three-quarter Saratoga Cup, which he won easily, falling just a second short of the record previously set by Reigh Count. After victories in both the Lawrence Realization and the Jockey Club Gold Cup at Belmont Park, Gallant Fox was retired to stud duty. His first crop of foals included Omaha, who would go on to win the Triple Crown in 1935. Gallant Fox thus became the only Triple Crown champion to sire another Triple Crown winner.

In the same year in which Omaha won the Triple Crown, Saratoga crowds witnessed the brilliance of the colt Discovery. A chestnut grandson of Fair Play (by Display), Discovery was well known for his ability to carry weights averaging 131 pounds, and sometimes up to 139 pounds. As a result, he was dubbed the "Iron Horse." After winning a string of races in 1935, Discovery edged out Omaha for Horse of the Year honors; it would be the only time that a reigning Triple Crown winner would be denied such a title. In the years 1934 through 1936, Discovery won three straight Whitney Handicaps—a feat that would not be duplicated until Kelso arrived on the scene in the 1960s. Discovery's other wins at Saratoga included the 1934 Kenner Stakes, the 1935 Merchants and Citizens Handicap, the 1935 and 1936 Wilson Stakes and the 1936 Saratoga Handicap.

Another key winner during the early 1930s was Equipoise, bred by Harry Payne Whitney and owned by his son, Cornelius Vanderbilt Whitney. Known affectionately as the "Chocolate Soldier" due to his rich coloring and elegant conformation, Equipoise was part of a group of horses dubbed by the *Chicago Tribune* as the "Big Four." Equipoise's wins at the Spa included the 1932 Whitney, the 1932 and 1933 Wilson Stakes and the 1933 Saratoga Cup.

The remaining members of the "Big Four"—Jamestown, Mate and Twenty Grand—also excelled on Saratoga's storied track. As a two-year-old in 1930, Jamestown captured four straight wins at the Spa: the Flash Stakes,

the U.S. Hotel Stakes, the Saratoga Special and the Grand Union Hotel Stakes. The following season, Preakness winner Mate captured the 1931 Kenner Stakes, while Twenty Grand, winner of the Kentucky Derby and Belmont Stakes, captured both the Travers and the Saratoga Cup.

As the summers progressed, Saratoga continued to showcase the best horses in the country, set against a peaceful and idyllic setting. During this period, additional trees, flowers and bushes were planted. Years earlier, a pond had been created in the infield, and a canoe floated above it, adding to the scenic ambience of the grounds. Horses were saddled among picturesque elm trees, and a large bell signaled the impending start of a key race. While the Depression continued, Saratoga retained its old-world charm, and patrons welcomed an escape from the financial problems plaguing the country.

A frequent visitor to the racetrack during this era was singer Bing Crosby, who had purchased his first racehorse in 1935. Crosby so loved horse racing that he eventually co-founded California's Del Mar racetrack, which would come to be known as the "Saratoga of the West." According to *Life* magazine, Crosby went to Saratoga every summer "to play golf and the horses—and

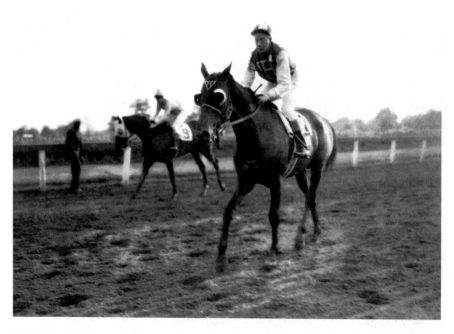

Seabiscuit with jockey Johnny "Red" Pollard. *Courtesy of the National Racing Museum and Hall of Fame.*

croon all night long at friends' parties for free." One of the singer's closest friends was Lindsay Howard, the son of businessman and racehorse owner Charles Howard.

In 1936, the elder Howard arrived in town to attend the annual yearling sales on Crosby's behalf. While at the track, a gangly, underweight plain bay with an unimpressive race record caught the businessman's eye. Howard noticed something special about the horse, a son of Hard Tack (by Man o' War) by the name of Seabiscuit. Howard followed his instincts and purchased the horse for a reported $8,000. Under the guidance of trainer Tom Smith and jockey Johnny "Red" Pollard, the colt won eleven of fifteen races and became the leading money winner of the 1937 season.

While Seabiscuit was racing primarily on the West Coast, another colt was winning multiple stakes races back east. War Admiral, a handsome son of Man o' War, was also owned by Sam Riddle. In contrast to his famous

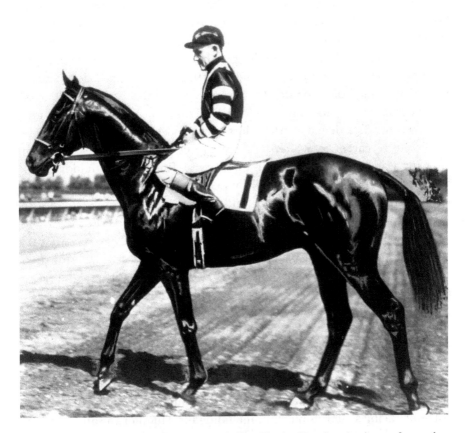

Triple Crown champion War Admiral (with jockey Charles Kurtsinger), winner of several stakes races at the Spa. *Courtesy of the Keeneland Library.*

sire, the "Admiral" was smallish in stature, with a shiny, seal brown coat that often appeared black. He did, however, possess the excitable temperament that had passed through the Fair Play line. War Admiral was regarded by his riders as difficult to handle, and he showed an aversion to the starting gate, which often delayed the start of his races by several minutes. Once loaded, however, he took command of the track.

War Admiral had seemed destined to race at Saratoga as a two-year-old, as the Spa was owner Sam Riddle's favorite summer getaway. The plan would not come to fruition, however, as the Admiral was stricken with a respiratory illness and was sidelined for the entire Saratoga meet. In his absence, Maemere Farm's colt Maedic dominated the Spa's two-year-old races, winning the Hopeful, Sanford, Grand Union Hotel, Flash and Saratoga Sales Stakes.

War Admiral bounced back in time for his three-year-old season and was unbeaten in eight starts, earning the Triple Crown and Horse of the Year honors in 1937. The following season, he arrived at Saratoga and dominated the dirt track, reeling off wins in all four major stakes races for older horses: the Wilson Stakes, Saratoga Handicap, Whitney Stakes and Saratoga Cup.

The Wilson Stakes, inaugurated in 1930, was a six-furlong sprint named in honor of Richard Thornton Wilson Jr., a past president of the racecourse who had passed away in 1929. The Admiral headed into the Wilson off a defeat in the Massachusetts Handicap, the only race in his entire career in which he finished out of the money. (The poor showing was later attributed to a foot injury.) Racing on a muddy track, the Admiral defeated a stellar Wilson field that included the mare Esposa (who had won the 1937 Whitney and had recently beaten Seabiscuit in record time) and Fighting Fox, a full brother to Gallant Fox. Esposa would prove to be a worthy opponent, as she went on to challenge the Admiral in the Saratoga Handicap, which the colt won by a neck. Esposa proved herself to be a gritty competitor, also placing second to the Admiral in both the Whitney Stakes and the Saratoga Cup.

Despite his many achievements, War Admiral became perhaps best remembered for a race that he did not win. In 1938, the Admiral was bested four lengths by Charles Howard's Seabiscuit in a much-publicized match race at Pimlico Race Course. Nevertheless, War Admiral remains one of Saratoga's—and racing's—greatest champions. Following his retirement to stud in 1939, his bloodlines would live on at Saratoga in some of racing's later immortals, including his daughter Busanda and his grandson Buckpasser.

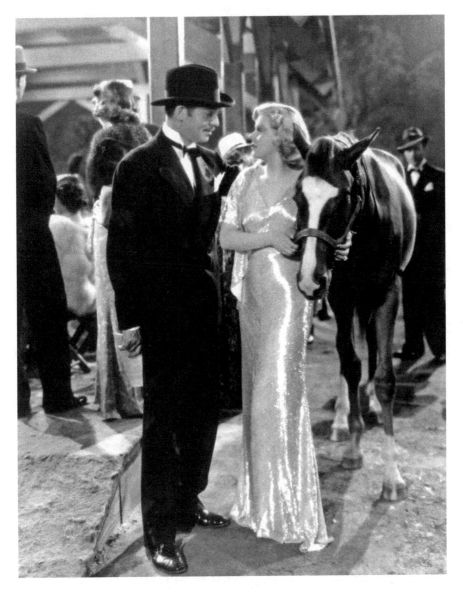

Publicity still for the film *Saratoga* starring Clark Gable and Jean Harlow. *Author's collection.*

Outside of the realm of racing, the track received national media attention with the release of an MGM film entitled *Saratoga*. The movie, which was partially filmed at the track itself (as well as in Kentucky and California), starred two of Hollywood's most famous stars, Clark Gable and Jean Harlow, in a lighthearted tale of romance at the races. In a

tragic turn of events, Harlow was stricken with nephritis during filming in California and passed away at the age of twenty-six. A stunt double was used to complete the film, which would go on to become the highest-grossing motion picture of the year. Likely as a result of Harlow's death, *Saratoga* was also one of the most widely talked about films of the era. Saratoga Race Course had become a permanent fixture in popular culture.

Chapter 10

WARTIME AND WINNERS

The onset of World War II at the end of the 1930s would dramatically impact American spending. For a while, however, it was business as usual at the racetrack, and patrons continued to spend their summers at the Spa—drinking, dining and betting on the horses. The year 1939 marked the establishment of the Diana Handicap, a mile-and-a-furlong-long race open to fillies and mares age three years and up. It was named not in honor of a horse but rather for the mythical goddess of the hunt. The inaugural winner of the Diana was War Regalia, a three-year-old chestnut by Man o' War. She was owned by Walter Jeffords (the husband of Sam Riddle's niece) and ridden by Don Meade. The *Times* wrote of her victory in the inaugural Diana, "Man o' War has been so long first in the hearts of American horse lovers that it seemed most appropriate that one of his daughters, War Regalia, was first today."[36]

Another key winner at Saratoga during this era was the colt Eight Thirty, who racked up four wins in a period of one month. After winning the 1938 Flash Stakes as a two-year-old (and setting a stakes record in the process), the chestnut colt returned to the Spa the following season and dazzled the crowds. He galloped to victory in the Wilson Stakes (which he won by four lengths) and captured the one-and-a-half-mile Saratoga Handicap three days later. The colt then went on to amass commanding wins in both the Travers and the Whitney. The latter was particularly impressive, as it occurred just days after the Travers and included a defeat of older horses. As a four-year-old, Eight Thirty defended his Wilson Stakes crown, defeating Esposa, the

only other starter, by a commanding four lengths. *American Race Horses 1940* stated, "Eight Thirty is considered by even the conservative horsemen as 'great among the great'—a truly magnificent performer that will never be forgotten and will long be quoted as a Thoroughbred of the highest chaste."

In the year after Eight Thirty's Whitney victory, the race was won by the four-year-old stallion Challedon, en route to earning Horse of the Year honors for the second consecutive year. Challedon was owned by Branncastle Farm and ridden by the legendary George "the Iceman" Woolf.

Several eventual Triple Crown winners would build their résumés at the Spa; one such horse was Whirlaway. A chestnut colt by Blenheim II, Whirlaway was gifted with a long, thick tail that earned him the nickname "Mr. Longtail." Whirlaway had another, less complimentary nickname given him by trainer Ben Jones of Calumet Farm. That moniker was "the HalfWit," as Whirlaway's seeming inability to run in a straight line frustrated the trainer.

Arriving at Saratoga in 1940 as a two-year-old, Whirlaway's penchant for zigzagging on the track cost him a victory in the U.S. Hotel Stakes, which was won by Attention, a son of Equipoise. In the Saratoga Special, Whirlaway was victorious, despite bearing out so dramatically that he made contact with the outer rail. Notwithstanding this victory, the frustrated Jones subsequently deemed Whirlaway the "dumbest horse [he'd] ever trained."

Jones continued to work patiently with the colt, and his hard work paid off with a key win in the Hopeful. This victory showed the horse's mettle, as, mid-stretch, Whirlaway had been hit in the eye by flying debris that injured his cornea. Through two months of vigorous treatment (which included consultations with human opthamologists), veterinarians were able to save the horse's eye.

By the time Whirlaway returned to Saratoga in the summer of 1941, he was the reigning Triple Crown winner. That summer he became the first and only Triple Crown champion to date to win the esteemed Travers Stakes. When Whirlaway retired from racing at the end of 1942, he had become the first horse to win more than half a million dollars.

As World War II raged on, its effects were soon felt at the racetrack. Government-ordered travel restrictions prohibited the transport of horses via rail, and Saratoga was closed from 1943 to 1945. Racing was moved to Belmont Park for all three seasons. Restrictions brought on by the war also impacted the annual Saratoga yearling sales. In 1943, Kentucky breeders sold their yearlings at a Fasig-Tipton sale that was held in a tent on the

Triple Crown
winner Whirlaway,
a multiple
stakes winner
at Saratoga.
*Illustration by Allison
Pareis.*

grounds of Keeneland Race Course in Lexington, Kentucky. As a result
of its initial success, Keeneland established its own auction company and
eventually replaced Fasig-Tipton as the premier thoroughbred auction
company in the United States.

As the war ended, attendance levels at Saratoga slowly began to increase,
and key races resumed. Race-goers in 1948 witnessed history in the making
when the great mare Gallorette defeated males to win the Whitney at the
age of six. She also won the Wilson Stakes in 1947 and 1948. In the book
The Great Ones, Ken Hollingsworth wrote of Gallorette, "She was a big mare;
as big as most of the colts she raced against, tougher than some of them,
faster than almost all of them." She retired at age six, following her Whitney
victory, as the all-time leading female money winner at the time. A daughter

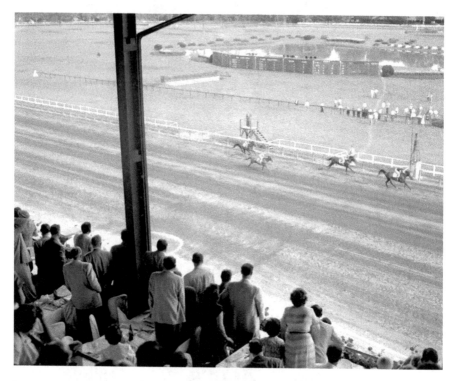

Busanda winning the 1952 Saratoga Cup. *Courtesy of the Keeneland Library.*

of Challenger II, the chestnut mare had an illustrious career, defeating, among others, eventual Kentucky Derby winner Hoop Jr. and multiple stakes winner Stymie. The latter's wins at the Spa included consecutive Saratoga Cups in 1945 and 1946 and the 1946 Whitney Handicap.

In the years following Gallorette's victories, another mare joined the list of great Saratoga champions. Busanda, an ebony-colored daughter of War Admiral, began her Saratoga winnings with a victory in the 1950 Alabama Stakes. Trained by Sunny Jim Fitzsimmons, she bested a field of males to win the 1951 Saratoga Cup, an accomplishment she repeated the following year. Busanda ended her career of sixty-five starts with a win in the 1952 Diana Stakes. Following that victory, she was retired to broodmare duty, where she would be mated with 1953 Horse of the Year Tom Fool. The resulting foal, Buckpasser, would make his own history at the Spa in the years to come.

Chapter 11

THE AGE OF MEDIA

The 1950s brought a new element to horse racing with the advent of the age of television. Key races could now be shown on TV, introducing the sport to a larger audience. Television created an array of new celebrities, and not all were human. One of the most popular stars of the early 1950s was a racehorse by the name of Native Dancer. He was owned by Alfred G. Vanderbilt II, a member of the prominent Vanderbilt family.

Known as "the Gray Ghost" due to his dazzling pale color, Native Dancer made quite an impression at Saratoga. In 1952, as a two-year-old, he captured a series of important juvenile races in his dramatic come-from-behind style. He won the Flash Stakes by two-and-a-quarter lengths, the Saratoga Special by three-and-a-half lengths and the Grand Union Hotel Stakes by a similar margin, carrying 126 pounds. He capped off these wins with a two-length victory in the Hopeful Stakes. Undefeated, Native Dancer became the first two-year-old to be named Horse of the Year.

Trainer Bill Winfrey told the media, "The gray is the fastest horse I've ever trained. He shows good times in workouts, but that's not what's impressive. It's the fact that the big gray does it without any effort. He actually seems to be holding himself back."

Native Dancer's stunning color, which was illuminated against the field of common chestnuts, blacks and bays, made him a perfect subject for television. The Gray Ghost became an instant hero. As his fan base grew, the horse's every move was followed by the media, and all of his major races were aired on TV by the CBS network. A survey by the magazine *T.V. Guide*

Native Dancer, "the Gray Ghost," with jockey Eric Guerin. Native Dancer's many wins included the Hopeful and Travers Stakes. *Courtesy of the Keeneland Library.*

noted that Native Dancer's popularity at that time was second only to entertainer Ed Sullivan as "the biggest attraction on television."

In the summer of 1953, three-year-old Native Dancer returned to Saratoga for the Travers Stakes. Fans followed him to the paddock, and his popularity mirrored that of a movie star. Prior to the race, a group of unruly fans pushed beyond the guards and pulled "souvenir" hairs from the horse's mane and tail. According to *The Unofficial Thoroughbred Hall of Fame*, "It was the first time a horse was almost trampled to death by humans, but Native Dancer recovered from the incident, easily winning the Travers by five and a half lengths."[37] He would retire with only one loss—to the long shot Dark Star in the Kentucky Derby. Native Dancer was also only the third horse (besides Duke of Magenta and Man o' War) to win the Preakness, Belmont and Travers in conjunction with the Withers Stakes at Aqueduct.

Native Dancer's biggest rival in the 1953 season was Tom Fool, a four-year-old bay colt owned by the Whitneys' Greentree Stable. Foaled one year prior to Native Dancer, Tom Fool had won five of seven starts in his two-year-old year, placing second in his remaining races and earning Champion Two-Year-Old Colt honors. Tom Fool's wins that season at the Spa included the Sanford Stakes and the Grand Hotel Stakes. He returned

to Saratoga the following year, winning the Wilson Stakes, a victory he would repeat the following season. His four-year-old year was perhaps his best, as he was undefeated in ten starts that included the Whitney. Based on that record, Tom Fool would edge out Native Dancer for 1953 Horse of the Year honors.

The appearance of these two outstanding horses brought summer racing to a new level. Many hoped that the two would face off on the racetrack; however, a recurring injury to Native Dancer's foot that season made such a meeting impossible. Tom Fool was retired to stud at the end of 1953, while Native Dancer raced for one more season and was named Horse of the Year for 1954. Both colts went on to successful careers in the breeding

Whitney Handicap champion Tom Fool and jockey Ted Atkinson. *Courtesy of the Keeneland Library.*

shed, siring a number of prominent stakes winners. Tom Fool's progeny, in addition to Buckpasser, included 1958 Kentucky Derby and Preakness winner Tim Tam. Native Dancer's offspring included Kauai King, who avenged his sire's one loss with a victory in the 1966 Kentucky Derby.

As Native Dancer and Tom Fool respectively made their way to the breeding shed, another superstar colt appeared on the scene. The bay colt Nashua, a son of the temperamental but speedy Nasrullah, arrived at the Spa as a two-year-old under the guidance of Sunny Jim Fitzsimmons. Nashua was bred and owned by the celebrated Belair Stud of William Woodward Jr., whose father, William Sr., had brought the farm to prosperity in the 1930s and '40s. Belair-

bred horses included Triple Crown champions Gallant Fox and Omaha, as well as key winners of premier British races such as the Epsom Oaks, St. Leger Stakes and 1,000 Guineas. Woodward Sr.'s success as a breeder led to his being featured on the cover of *Time* magazine in August 1939.

With the death of the elder Woodward in 1954, William Jr. inherited the farm, which included Nashua. The colt raced eight times as a juvenile, amassing six wins and two second-place finishes. Nashua's victories at Saratoga that summer included the Grand Union Hotel Stakes, which he won by a length and three quarters, and the Hopeful Stakes, which he captured by a neck over rival Summer Tan. After winning champion two-year-old colt honors, Nashua embarked upon a highly successful three-year-old season, in which he won the Preakness and Belmont Stakes under jockey Eddie Arcaro.

Nashua's second-place finish in the Kentucky Derby led to a rivalry with the California-based winner, Swaps. In response to this rivalry, a match race between the two horses was arranged for August 31, 1955, at Washington Park in Chicago. Rather than preparing Nashua in the Windy City, however, Fitzsimmons opted to work the colt at Saratoga. Fitzsimmons remarked, "Training in Saratoga makes a horse fit. In a match race the object is to run from the gate, and the fittest horse wins."[38] The plan worked, and Nashua bested a less-than-perfect Swaps by six lengths, earning the $100,000 purse. Nashua was subsequently named 1955 Horse of the Year.

Nashua's story would gain additional media coverage when, in an odd twist of fate, William Woodward Jr. was shot and killed in his home on Halloween night in 1955. The murder was committed by Woodward's wife, Ann, who claimed to have heard an intruder and accidentally shot her husband instead. Woodward's death made worldwide headlines, with *Life* magazine referring to it as the "Shooting of the Century," and spurring storylines for novels by acclaimed writers Truman Capote and Dominick Dunne.

In the aftermath of Woodward's death, Nashua was sold in a sealed-bid auction. He became the first racehorse to be sold for $1 million when he was purchased by a syndicate led by Leslie Combs II of Spendthrift Farm for the sum of $1,251,200. Nashua retired to stud in 1956, having surpassed the earnings record previously set by Triple Crown champion Citation.

Meanwhile, exciting improvements had been made at the racecourse. In 1950, Cornelius Vanderbilt "Sonny" Whitney (son of Harry Payne Whitney and Gertrude Vanderbilt) had led the establishment of the National Racing Museum in Saratoga Springs. The idea was to create a permanent home for various racing artifacts and memorabilia, as well as a Hall of Fame that

Nashua and jockey Eddie Arcaro. The pair's many wins included the Hopeful and the Grand Union Hotel Stakes. *Courtesy of the National Racing Museum and Hall of Fame.*

would honor the jockeys, trainers and horses that had contributed to the sport of kings. Morrissey's former Club House, the Canfield Casino, became the original and temporary site of the museum, beginning on August 6, 1951. Sonny Whitney served as the museum's first president, a position he would maintain until 1953. The museum was an instant success, with more than 8,000 people visiting the site in 1951. That figure increased the following year, with 11,500 visitors recorded by December 1952.

Meanwhile, the structure of Saratoga racing changed when state legislators determined that a nonprofit association should be formed to oversee New York racing. This resulted in the formation of the Greater New York Association (GNYA). In 1955, shareholders of the four New York racetracks operating at that time (Saratoga, Jamaica, Belmont and Aqueduct) sold out to the GNYA, with Saratoga shares purchased at a cost of $102 each. The GNYA was later renamed the New York Racing Association (NYRA). One of its original founders was Christopher T. Chenery, who would later become well known as the breeder of Secretariat.

Also in 1955, the National Racing Museum moved to its permanent location at the corner of Union Avenue and Ludlow Street (across from the racecourse) in a building constructed specifically to house it. A formal dedication was held on August 16 of that year, with New York governor W. Averell Harriman presiding over the event. (Harriman was no stranger to the Spa, as he was the owner of 1927 Saratoga Cup winner Chance Play.) Those in attendance for the dedication included, among others, jockeys Eddie Arcaro and Ted Atkinson; Claiborne Farm's Arthur B. Hancock, representing the American Breeders' Association; and Christopher T. Chenery, representing the GNYA. According to an article by the *Times*, Harriman concluded his day with a trip to the races.

The Racing Museum's first official artifact was a shoe from the inaugural Travers winner, Kentucky, donated by steward Harold O. Vosburgh. Other memorabilia soon followed. The Hall of Fame inducted its first group in 1955; included in this distinguished group, among others, were the horses Boston, Lexington and Hindoo; jockeys Isaac Murphy, George Woolf and Earl Sande; and trainers Sam Hildreth and James Rowe Sr.

The Racing Museum in its new location formally opened to the public on June 2, 1956. The following year, a wing was added to house a special collection of horse racing–related art. Since that time, the museum has undergone numerous expansions and renovations and has become an important part of the Saratoga experience—and the racing industry as a whole.

Following the establishment of the National Racing Museum and Hall of Fame, the racecourse continued its climb into popular culture when author Ian Fleming chose it as a setting for his latest novel in the James Bond "007" series, *Diamonds Are Forever*. The novel would be made into a film in 1971, with Sean Connery resuming his role as the spy James Bond. In later years, the racecourse would be referenced in various works of literature and would serve as the setting for several motion pictures.

Meanwhile, changes to the New York racing establishment continued through the mid-1950s, as GNYA announced its plans to close the Jamaica track and establish a new, modernized facility at Aqueduct. As the revenues from the tracks in lower New York were higher than those at Saratoga, there was discussion of running a race meet downstate simultaneously with the traditional Saratoga meet. In response, a bill was proposed that would guarantee twenty-four days of exclusive racing at Saratoga. In 1957, Governor Harriman, who had presided over the opening of the Racing Museum, signed a bill that ensured a minimum of twenty-four race days at the Spa each year. Saratoga would remain, as it had always been, the August place to be.

Chapter 12

ONE HUNDRED YEARS
OF GREATNESS

B y the turn of the decade, enhancements continued to be made and new traditions were begun at the Spa. In 1962, a practice was begun whereby the stable colors of the annual Travers winner would be painted onto a canoe situated on the pond in the infield. The canoe, a long-standing presence at the Spa, is now annually repainted with the colors of the newest Travers champion. Jaipur, the winner of the 1962 Travers, was more than worthy of such an honor, as his victory was one of the most exciting in Saratoga history.

A dark bay son of Nasrullah, Jaipur entered the Travers as the reigning Belmont Stakes winner and the favorite in the seven-horse field. The previous season, he had been victorious at the Spa, winning both the Flash and the Hopeful Stakes for juveniles. Jaipur's biggest rival in the Travers, and the second betting choice, was Ridan, a bay colt who also traced his recent lineage to Nasrullah. Ridan had set a new speed record while winning the Hibiscus Stakes at Hialeah earlier that year and followed with wins in both the Blue Grass Stakes and the Florida Derby. As both horses had excelled on the track that season, the Travers would likely determine which would be named champion three-year-old colt.

Jaipur, ridden by Willie Shoemaker, and Ridan, piloted by Bill Hartack, met head to head early in the race and began what was to be a valiant duel for the entire mile and a quarter. Jaipur, on the outside, and Ridan, on the rail, battled neck and neck, leaving the rest of the field—which included the champion filly Cicada—in their wake. In what has been

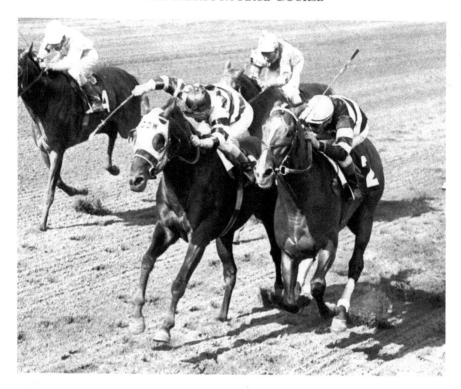

The duel between Jaipur and Ridan in the 1962 Travers Stakes. *NYRA photo, courtesy of Adam Coglianese.*

widely viewed as one of the most memorable runnings of the Travers—or any race, for that matter—Jaipur ultimately edged out Ridan by the narrowest of fractions—a nose. A new track record was set with the winning time of 2:01 60, and Jaipur won the expected Horse of the Year honors. The Jaipur-Ridan showdown was deemed by the *Blood-Horse* as one of "Horse Racing's Top 100 Moments" in the book bearing that same name. For his part, Ridan overtook both Jaipur and the great Kelso the following season, winning the Palm Beach Handicap at Florida's Hialeah Park.

The summer of 1963 was one of jubilance at the Spa, as the racetrack celebrated its 100th anniversary with a series of events. Lavish parties were held, parades lined the streets and tributes to past champions were held. Feature articles in national magazines, including *Life, Sports Illustrated* and *Time*, heralded the anniversary of the Spa and looked back on its colorful one-hundred-year history. *Time* wrote of the festivities:

Dawn at the track in 1963. *Courtesy of the Library of Congress.*

Last week everybody celebrated—inlanders and outlanders alike. Bearded men and crinolined ladies bounced through the streets in horse-drawn carriages; diamonds glistened like dewdrops of Saratoga Vichy at black-tie parties. Sousaphones harrumphed, fireworks whiz-banged, and chicken sizzled to a crunchy golden brown. Welterweight Champion Emile Griffith was signed for a nontitle fight; Arnold Palmer and Gary Player were booked for an exhibition golf match. All in all, just the sort of shindig that would have delighted John Morrissey—the man who started the whole bawdy binge a century ago.[39]

Coinciding with this key anniversary, many improvements were made at the Spa. These included the addition of a 550-foot section to the grandstand and the construction of a new roof. Additional amenities for enhanced spectator comfort included new cafés, ventilation systems and escalators.

History continued to be made at the Spa throughout the 1960s, with the immensely popular Kelso winning his third Whitney Stakes in 1965 at the age of eight; to date, he remains the oldest winner of that race. One of the greatest geldings of all time, Kelso was named Horse of the Year for five consecutive years from 1960 to 1964. A genuine equine superstar, he was featured on the cover of *Sports Illustrated* in 1961 and was profiled in *Look* magazine four years later. Kelso was bred and owned by Mrs. Allaire

Three-time Whitney winner Kelso, shown in the paddock at Belmont with jockey Eddie Arcaro and trainer Carl Hanford. *Courtesy of the Keeneland Library.*

DuPont of Maryland and was named in honor of her friend, Kelso Everett. The gelding's multitude of fans, who often brought banners and signs to his races, called their hero "King Kelly."

Ridden by Eddie Arcaro, Kelso had won his first Whitney in 1961 as a four-year-old while carrying a whopping 130 pounds. He won a purse race on the Spa's turf course as a five-year-old and returned the following year to win his second Whitney. A testament to the gelding's talent, Arcaro (whose many great mounts had included Whirlaway, Citation and Nashua) noted that he "had never ridden a better horse."[40]

When Kelso returned to Saratoga for his third Whitney in 1965, many doubted whether the eight-year-old veteran could pull off another win. Many had expected him to retire at the end of the previous season and were surprised when he resumed training in June 1965. In three starts that season, Kelso had only managed one win, which occurred in the Dover Stakes at Delaware Park.

Heading into the 1965 Whitney, the *Daily Racing Form* had selected the four-year-old colt Pia Star as its favorite. The colt was coming off four

straight victories that included a defeat of Kelso in the Brooklyn Handicap. Also in the field of five was Greentree Stables' colt, Malicious, winner of the previous year's Jim Dandy Stakes. Nevertheless, the crowds opted for Kelso, and he was sent off as the betting favorite while carrying the high weight of 130 pounds. A crowd of over 23,300 was on hand to watch the race, with many fans waving banners extolling the virtues of King Kelly. According to *Sports Illustrated*, approximately 12,000 fans lined the Spa's paddock area to gain a glimpse of their equine hero.

The race began quickly as Malicious, carrying 114 pounds, grabbed the early lead. Jockey Ismael Valenzuela, sensing a threat, went to his whip and urged Kelso along. The crowd went wild as the champion made his move, overtaking Malicious by the narrowest of margins as the two horses approached the finish line. The *Albany Times Union* wrote, "This time the 'old man of racing' came on like gangbusters and the din was overwhelming as he beat out Malicious in a final lunge at the wire."[41] Kelso had proven his mettle with a winning time of 1:49 ⅘—a mere ⅘ of a second behind the track record.

Shortly after Kelso's Whitney victory, the Spa was graced with the presence of three spectacular colts who would dominate East Coast racing in the late

Buckpasser, winner of the Hopeful and Travers Stakes. *Illustration by Allison Pareis.*

1960s. Buckpasser, Damascus and Dr. Fager became thoroughbred racing's "Big Three." Over the next few years, each would contribute a key piece in the history of the Spa.

Buckpasser, bred and owned by Ogden Phipps, was revered for his stunning good looks and mellow temperament. Famed painter Richard Stone Reeves would describe Buckpasser as "the most perfectly proportioned thoroughbred" he had ever seen. In terms of manners, Reeves had noted that if the great thoroughbred were able to talk, he likely would have offered the artist "a seat and perhaps a drink."[42]

Buckpasser arrived at the Spa as a juvenile and was entered in the Hopeful Stakes. Falling to his knees when the starting gate opened, Buckpasser quickly recovered and showed the resilience of a much older veteran. Ridden by Braulio Baeza, the brown colt made his move at the half-mile pole to reach leaders Indulto and his own stable mate, Impressive. Buckpasser gained speed at the eighth pole, ultimately winning the race by two and a half lengths and leading *Sports Illustrated* to declare him "the horse to beat."[43] At the end of that season, Buckpasser was named champion two-year-old colt.

Buckpasser continued to demonstrate his greatness when he returned to the Spa the following summer. In the Travers on August 20, Buckpasser contained himself for a bit before eventually overtaking Amberoid (the reigning Belmont Stakes champion) for a three-quarter-length victory. In the process, he matched the track record of 2:01 ⅗ for ten furlongs. Named 1966 Horse of the Year, Buckpasser was the sport's first three-year-old to surpass the million-dollar earnings mark.

In the year following Buckpasser's Travers win, another brown colt stepped up to win the midsummer derby in dramatic fashion. Damascus, a son of 1959 Travers winner (and Horse of the Year) Sword Dancer, was bred and owned by Mrs. Edith W. Bancroft, daughter of William Woodward Sr. Damascus was known for his nervous personality, which some felt cost him the Kentucky Derby, as he had difficulty settling and was distracted by the raucous crowds. After a disappointing third-place finish at Churchill Downs, the colt was given a stable pony for company in an effort to calm his nerves. The plan appeared to be successful, and a less anxious Damascus dominated both the Preakness and the Belmont Stakes.

Following these wins, only three horses opted to challenge Damascus in the Travers. Jockey Bill Shoemaker held him third in the four-horse

field, as the speedy Tumiga and Gala Performance battled neck and neck in front. The two opened up a fifteen-length lead at the half-mile pole before tiring. Damascus, coming steadily from behind, surged to the front in the stretch, ultimately overcoming the field by an astounding twenty-two lengths. In the process, Damascus equaled the track record of 2:01 ⅗ for a mile and a quarter.

The third member of racing's "Big Three" of the 1960s made history in the 1968 Whitney Stakes. Named for Dr. Charles Fager, a prominent brain surgeon who had saved trainer John Nerud's life, Dr. Fager entered the Whitney after being defeated by Damascus in the Brooklyn Handicap. "The Doctor" was back in winning form at the Spa, where he romped to an eight-length victory. Dr. Fager's post-time betting odds of 1-20 set a new record for New York racing, and he carried the most weight to date (132 pounds) by a Whitney champion. At year end, the versatile Dr. Fager received numerous accolades, being named Horse of the Year, champion handicap horse, champion sprinter and co-champion turf horse.

In the year following Dr. Fager's historic Whitney win, another colt dazzled the crowds that had packed into Saratoga's grandstand. Paul Mellon's Arts and Letters, a son of the undefeated European champion Ribot, was coming off a five-and-a-half-length victory in the 1969 Belmont Stakes when he made his way to Saratoga. The win had been notable, as Arts and Letters finally overtook his rival, Majestic Prince, who had bested the Mellon-owned colt in both the Kentucky Derby and Preakness Stakes.

Arriving at the Spa that summer, a well-rested Arts and Letters captured the Jim Dandy Stakes before putting on a display of pure talent in the Travers. It was the historic hundredth running of the race, which had not been run several times under "Dutch Fred" Walbaum's regime in the late 1800s. A crowd of 28,017 was on hand on that humid August day, hoping that a threat of rain would hold off and, more importantly, that history would once again be made.

Arts and Letters rose to this festive occasion, bolstered by the cheers of adoring fans as he battled with a late-closing colt named Dike. Arts and Letters won by more than six lengths, equaling the track record of 2:01 ⅗ for the mile and a quarter. *Sports Illustrated* wrote, "Not since the days of Kelso, and before that Native Dancer, has the Saratoga paddock been as jammed as it was on race day when Arts and Letters brought up the rear of the five-horse post parade prior to the Travers...With the wonderfully smooth, rhythmic strides that often distinguish a great horse from a good

one. Arts and Letters began eating up his field. The enthusiastic crowd leaped up, and its cheers rolled in one loud wave across the lush infield."[44] For a while, it appeared that racing at the Spa could not possibly get any better.

Chapter 13

A Tale of Two Champions

As the first glints of late summer dawned in 1972, a new sensation arrived at the Spa. With near perfect conformation and the striking looks of a matinee idol, a two-year-old named Secretariat commanded attention when he set foot on Saratoga's historic grounds. Even his nickname evoked greatness; like the immortal Man o' War, the chestnut colt was affectionately called "Big Red." Secretariat would be entered in three races at the Spa that summer: an allowance race, followed by the Sanford and Hopeful Stakes.

A son of Bold Ruler out of the mare Somethingroyal, Secretariat was bred and owned by Christopher T. Chenery's Meadow Farm in Virginia. Chenery, one of the original founders of the NYRA, had established the farm in 1932 and bred thoroughbreds under the Meadow Stud banner. The farm had produced several champions, including 1950 Horse of the Year Hill Prince; Cicada, the first filly to win championship honors as a two-, three- and four-year-old; and First Landing, champion two-year-old colt in 1958. By the time of Secretariat's birth in 1970, the ailing Chenery had been hospitalized for two years; in her father's absence, daughter Helen "Penny" Chenery Tweedy had taken over the farm's operations.

First Landing had experienced triumph at the Spa, winning the Hopeful and the Saratoga Special in 1958. He also had success in the breeding shed; in 1969, First Landing sired a bay colt who was christened Riva Ridge. The name was in tribute to Penny's husband, John Tweedy, who

had served in World War II and had been a part of a U.S. victory at Riva Ridge in Italy.

On August 2, 1971, the two-year-old Riva Ridge impressed the masses at Saratoga with a resounding victory in the Flash Stakes by two and a half lengths. The colt ran three-quarters of a mile in 1:09 ⅘, a mere ⅗ of a second off the existing track record. The following spring, he continued his winning ways, taking both the Kentucky Derby and Belmont Stakes.

Spring turned into summer, and the horses began to arrive at Saratoga. Riva Ridge returned to the Spa, along with his younger stable mate, Secretariat. In the latter's maiden outing on July 4 at Aqueduct, he had run into trouble but recovered well, moving up to a fourth-place finish over five and a half furlongs. Eleven days later, he broke his maiden under jockey Paul Feliciano in a six-furlong maiden special weight. Secretariat demonstrated raw power in both of these races, starting out from behind and gradually making his move before taking over in mid-stretch. In breaking his maiden by an impressive four lengths, Secretariat caught the attention of racing's elite.

Secretariat's first race on the hallowed Saratoga track was a six-furlong allowance on July 31. He was paired with a new rider, the Canadian-born Ron Turcotte, who was also the primary jockey for Riva Ridge. It was another impressive win for Big Red, who proved himself ready for stakes company. In preparation for the Sanford Stakes to be held on August 16, Secretariat posted the fastest workout of his life for trainer Lucien Laurin. Five days before the Sanford, the colt ran five-eighths of a mile in fifty-nine seconds flat.

Despite this blazingly quick workout, Secretariat was actually sent off as the second betting favorite in the Sanford at post-time odds of 3-2. The bay colt Linda's Chief was the favorite at 3-5 in the five-horse field. Once again, Secretariat proved he was something extraordinary, winning the race by open lengths. He completed the six furlongs in 1:10, the fastest time for that distance at Saratoga in 1972. The previously undefeated Linda's Chief finished a disappointing second.

Returning to the track on August 26 for the Hopeful, Secretariat did not disappoint, winning by five lengths. In the process, he passed eight other horses in his quest toward the finish line. The *Daily Racing Form* noted, "Secretariat, outrun away from the gate, looped his field on the turn to reach the front approaching the stretch and drew off with authority."[45] At the end of the season, Secretariat was not only named champion two-year-old colt but also the overall Horse of the Year.

A Tale of Two Champions

Secretariat's popularity increased tremendously when he won the Triple Crown in 1973, becoming the first horse to do so in twenty-five years. The early 1970s was a time of unrest in America, and the red horse fulfilled the country's need for a hero. His win in the Belmont Stakes by thirty-one lengths is considered one of the greatest moments in the history of sports. When he returned to Saratoga for the Whitney Handicap, nearly nine thousand fans packed themselves near the backstretch gate to catch a glimpse of the "Superhorse." While Secretariat had lost races in the past, in the summer of 1973 he seemed all but invincible. In preparation for the Whitney, the colt posted a mile workout of 1:34 over the muddy Spa track. This time was four-fifths of a second behind the existing track record, which had not been touched in fifty-five years.

Full of power and seemingly larger than life, Big Red entered the Whitney on August 4 as the odds-on favorite. Also in the race was a colt called Onion, who had his own set of credentials. At the Spa eleven days prior to the Whitney, Onion had set a new track record at six and a half furlongs.

Onion was an early leader and rushed to the front as the starting gates opened. Secretariat waited it out, preparing to make his characteristic move near the far turn. When he reached the leader, the two colts dueled until the final sixteenth. Despite urging from Turcotte, however, Secretariat weakened, and Onion bested the Triple Crown champion by a length. After the race, Secretariat was found to be suffering from a virus that had likely impacted his physical stamina.

Following this race, Onion's trainer, Allan Jerkens, would be nicknamed the "Giant Killer," due to his apparent knack for defeating odds-on favorites. Jerkens's Handsome Boy had defeated the great Buckpasser in the 1967 Brooklyn Handicap, and his Beau Purple bested Kelso three times while the latter was the reigning Horse of the Year. One month after the Whitney, Jerkens would get the best of Secretariat once more, when his 16-1 entry, Prove Out, conquered Big Red in the Woodward at Belmont.

With Secretariat's loss to Onion in the Whitney, Saratoga continued its reign as the "graveyard of champions." The trend had also impacted Riva Ridge, who was surprisingly defeated three days earlier by a 51-1 long shot named Wichita Oil. That summer, there had been plans to organize a match race between the Derby-winning stable mates Secretariat and Riva Ridge. Following these two upsets, it was jokingly suggested that the match race be a duel between Onion and Wichita Oil.

Secretariat's defeat at the Spa did nothing to diminish his reputation, and he would be widely considered—alongside Man o' War—as one of the top two racing thoroughbreds in the history of the sport. The Whitney was to be Secretariat's last race at Saratoga, as he retired to the breeding shed after the 1973 season. His brilliance would live on in his offspring, who would win key races at the Spa in the years to come.

While Secretariat settled into his new career as a breeding stallion, another superstar arrived at Saratoga. Ruffian was a tall, two-year-old filly with the steps of a ballerina and the speed of a locomotive. She had broken her maiden at Belmont Park her first time out, demolishing the field by fifteen lengths and equaling the track record of 1:03 for five and a half furlongs. She then took the Fashion Stakes by six and three quarter lengths, once again equaling the existing track record. Ruffian capped off these wins with a nine-length victory in the Astoria Stakes at Aqueduct, and if that were not enough, she set a new stakes record in the Sorority Stakes at Monmouth with a time of 1:09. Not only had Ruffian never been beaten, but the coal-colored filly had never been headed.

The "Queen of the Fillies," as her fans dubbed her, would attempt to continue that record in the six-furlong Spinaway Stakes. Her arrival at Saratoga caused an immediate sensation with the media. The filly was coming off a four-week layoff for a popped splint, which was noticed following her victory in the Sorority Stakes. As groom Minnor Massey unloaded the filly from the van, a reporter asked him to estimate Ruffian's eventual winning margin. Massey quickly replied that the filly would win by thirteen lengths.

In her five-furlong workout the following day, Ruffian posted a "bullet"—the day's best workout, as reported by the *Daily Racing Form*. This time, while the fastest of the day, was not the outstanding speed expected of the superfilly. The Unofficial Thoroughbred Hall of Fame wrote, "Had any other horse turned in a time of 0:59 ⅕, the clockers would have been impressed. But for Ruffian, the work was not spectacular enough." As a result, rumors began to circulate that Ruffian was still bothered by injury.

Any questions about the filly's soundness were quickly dispelled when Ruffian took to the track for the Spinaway. Only three other fillies— Laughing Bridge, Scottish Melody and Some Swinger—dared to face Ruffian on the Saratoga track. Leading wire to wire under jockey Vince Bracciale Jr., *Sports Illustrated* noted that "the filly...was almost unbelievable."[46] Laughing Bridge, a double stakes winner at the Spa,

finished nearly thirteen lengths back, with Scottish Melody another length behind and Some Winger finishing nineteen lengths behind the winner. Ruffian, for her part, made the victory appear effortless. *Sports Illustrated* wrote:

> *Taking the lead at the start, Ruffian loped along in beautiful reaching strides that gave no immediate impression of speed. The trio behind her hustled in vain to keep up, or even to maintain any sort of position from which to make a stretch challenge. Ruffian, seemingly coasting, raced through the first quarter in 22 [$^1/_5$] and the half mile in 44 [$^4/_5$], opening a seven-length lead. She kept striding gracefully away from her pursuers, increasing her lead with almost ridiculous ease.*[47]

Ruffian's winning time of 1:08 ⅗ had shattered the previous Spinaway record of 1:09 ⅕ set by Numbered Account in 1971. It also surpassed the time of 1:09 ⅕ logged by Sopranist in 1945, when the Spinaway was run at Belmont Park due to wartime restrictions. Even more impressively, Ruffian ran the fastest time for six furlongs for a two-year-old (colt or filly) running at the Spa, all while carrying 120 pounds.

While many prominent fillies had won the Spinaway in years past, the attention on these victories was generally eclipsed by the races that followed. The celebrated filly Moccasin had won the Spinaway in 1965, only to be upstaged by Buckpasser's win in Hopeful the following afternoon. And in 1972, one day after the undefeated La Prevoyante won the Spinaway, Secretariat stole the spotlight with his Hopeful victory. With Ruffian, however, it would be different; before and following the running of the Hopeful, the track was abuzz with talk of Ruffian's brilliance. Her performance impressed even the toughest of critics. Hours after Ruffian's historic win, Secretariat's trainer Lucien Laurin allegedly told reporters, "As God is my judgment, this filly may be better than Secretariat!"[48]

Sadly for racing fans everywhere, Ruffian would never run again at Saratoga. After she won the "filly triple crown" as a three-year-old, a match race was suggested between Ruffian and the reigning Kentucky Derby winner, Foolish Pleasure. It was heralded as a duel between the sexes, with the nation's top filly taking on the leading colt. A crowd of fifty thousand fans was in attendance on July 6, 1975, to watch the showdown at Belmont Park. Leading at the half-mile mark, Ruffian took a misstep, fracturing both sesamoid bones in her right foreleg. Emergency surgery was performed to repair the injuries, but efforts to save the great filly were

futile. While awakening from surgery, she began to thrash around, causing further irreparable damage to her legs, giving veterinarians no choice but to euthanize the filly. In an ultimate tribute to her greatness, Ruffian was buried near the flagpole at Belmont Park, with her nose pointing toward the finish line.

Ruffian's death shook the racing world to its core and reminded race-goers of the fragility of life. Her speed record at Saratoga remains untouched, and she has earned herself a permanent place among the sport's all-time greats. The memories of her glorious trip, and the beautiful, dark filly that could run like the wind, remain etched forever in the history of the Saratoga Race Course.

Chapter 14

TALK OF THE TOWN

A ll sports have their share of great rivalries. When two competitors possess an equal amount of talent and drive, they push each other to new levels of excellence. Boxing had Ali and Frazier. Basketball had Chamberlin and Russell. Baseball had DiMaggio and Williams. And in the 1978 season, horse racing at Saratoga had Affirmed and Alydar.

Affirmed, trained by Laz Barrera, had won seven of his nine starts as a two-year-old under teenage jockey Steve Cauthen. Affirmed was a front runner who enjoyed having the lead, a style that appeared to serve him well. The Calumet-bred Alydar, however, preferred to hang back before making his move. With two very different running styles, the meetings between Affirmed and Alydar would prove to be especially exciting.

The two chestnut colts had first met at Belmont Park for the Youthful Stakes in 1977. The five-and-a-half-furlong outing was Alydar's first start, while Affirmed had already broken his maiden. Affirmed took the win in this first matchup between the two, while the less experienced Alydar failed to challenge and placed fifth. This would be the only race in which the two were running that they did not place first and second. Often Affirmed would prevail, and other times Alydar would be the winner, setting off a thrilling rivalry for the ages.

By the end of their two-year-old season, the colts had met six times, with Affirmed taking four wins to Alydar's two. One such meeting was the Hopeful, with Affirmed overtaking Alydar by a half length. Affirmed

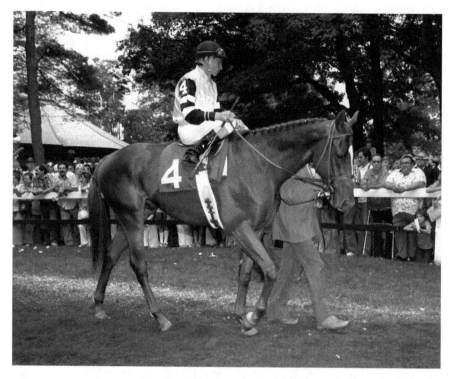

Affirmed and jockey Steve Cauthen. *NYRA photo, courtesy of Adam Coglianese.*

also won the Sanford Stakes, a race that Alydar did not start. At year end, Affirmed secured champion two-year-old colt honors.

Heading into the Triple Crown races, the two colts had taken separate paths. Alydar had a more stellar prep season and entered the Kentucky Derby as the 6-5 favorite. Under the historic twin spires at Churchill Downs, however, Affirmed held off his rival to capture the coveted garland of roses by one and a half lengths. In the Preakness, Affirmed prevailed by a neck over Alydar and took the Belmont by a mere nose after an exciting stretch duel to win the Triple Crown. Alydar became the first horse to place second in all three Triple Crown races, losing by a combined margin of fewer than two lengths. And in the races in which he did not face Affirmed that season, Alydar maintained a perfect record.

The rivalry was in full force when the two colts shipped to Saratoga, where they would be reunited in the Travers Stakes. Prior to this race, Alydar took on six older horses in the Whitney, carrying a hefty 123 pounds. Only one other three-year-old, Buckaroo, was entered in this race, and he carried 11

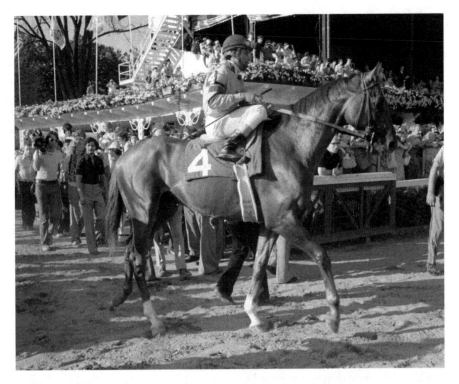

Alydar goes to post in the 1978 Travers with jockey Jorge Velasquez. *NYRA photo, courtesy of Adam Coglianese.*

pounds less than Alydar. The strong field included the speedy J.O. Tobin, who, like Affirmed, was trained by Laz Barrera. Also racing was Nearly On Time, who had won the Whitney the previous year. Despite these formidable opponents, Alydar was clearly the celebrity in the race. As he headed to the paddock for saddling, a crowd of more than 1,500 fans gathered around the elm tree that bore his number. *Sports Illustrated* wrote, "When he paraded to the post, the largest Whitney crowd in history, 31,034, applauded him. The noise started in the grandstand, moved down the track and into the clumps of fans in the infield."[49]

Alydar did not disappoint his fans, winning the Whitney by a commanding ten lengths as Buckaroo and Father Hogan battled for second. In doing so, Alydar became only the tenth three-year-old thus far to win the Whitney. With Alydar cementing his reputation among the greats, attention turned to his upcoming meeting with Affirmed in the Travers. The two colts, and the upcoming Travers, had become the proverbial talk of the town, as fans wondered which of the two colts would prevail.

As Alydar rested following his Whitney victory, Affirmed took to the track for the Jim Dandy Stakes, where he would face a field of four speedsters while carrying the top weight of 128 pounds. Affirmed, like Alydar, rose to the challenge, closing in on the Allan Jerkens–trained colt, Sensitive Prince, for a courageous half-length win. Trainer Laz Barrera called this race "one of [Affirmed's] finest efforts." With the two champions now coming off individual victories, it was time for the true battle to begin.

Race-goers had high hopes for a thrilling encounter as the two colts took to the track on August 19. Affirmed was ridden by jockey Laffit Pincay, as Cauthen recovered from a fall sustained the day after the Jim Dandy. Affirmed went off as the 3-5 favorite in the four-horse field that included Brooklyn Handicap winner Nasty and Bold. A record crowd of 50,122 was on hand to watch the Affirmed-Alydar showdown.

The early (albeit slow) pace was set by Shake Shake Shake and Angel Cordero Jr., with Affirmed cruising behind the leader through the first three-quarters of a mile. As Affirmed overtook the leader, Alydar and jockey Jorge Velasquez made their characteristic move along the rail. Suddenly, Alydar appeared to stumble, nearly stopping in his tracks and falling behind by nearly six lengths. Recovering quickly, Alydar gained composure and returned to challenge Affirmed in the stretch but was unable to overtake the fast-closing Triple Crown winner. Affirmed finished first by one and three-quarter lengths over his rival. Subsequent to crossing the finish line, an inquiry was posted. Affirmed was charged with interference, and Alydar was declared the winner. The two champions would never meet again on the racetrack. It was a disappointing finale to the rivalry between two legends of the sport.

For Alydar's trainer, John Veitch, the last few years had been exceptionally memorable. As he headed back to the stables following Alydar's win, he stopped to visit with another of his champions. Our Mims, the half sister of Alydar through the mare Sweet Tooth, was a star at Saratoga in her own right. One year older than her famous half brother, Mims was foaled in 1974 at Kentucky's famed Calumet Farm.

After a slow start as a juvenile, Our Mims showed initial signs of brilliance in her three-year-old season. She won her first outing, an allowance race at Florida's Hialeah Park, and followed it up with a string of victories that included the Fantasy Stakes at Oaklawn and the Coaching Club American Oaks at Belmont Park. That spring, she placed an impressive second in a field of twelve starters in the Kentucky Oaks at Churchill Downs.

On August 13, 1977, Mims put in a valiant effort over the Spa's dirt track to win the grade one Alabama Stakes. Included in the field for the Alabama

was the 1976 two-year-old champion filly Sensational, a dark bay daughter of Hoist the Flag. For this race, Mims was saddled by Veitch's father, Syd, as John was preparing Alydar for the Sapling Stakes in New Jersey.

Following her win at Saratoga, Mims was victorious in the Delaware Handicap, securing honors as champion three-year-old filly. She was also the subject of much-deserved praise. Commentating for CBS Sports, announcer Jimmy "Jimmy the Greek" Snyder stated his belief that Our Mims was "the only horse that could beat Seattle Slew," the celebrated reigning Triple Crown champion.

Our Mims returned to the Spa in the summer of 1978 but fractured the cannon bone in her right front leg during a morning workout. She was retired to Calumet Farm, where she became a key member of the farm's broodmare band. After producing several foals, Mims became barren in her early twenties. The now financially troubled Calumet held a dispersal sale in 1990, during which the gallant mare was sold. Away from the glamour of the winner's circle, the champion's tale took a sad and unusual turn. Our Mims, champion filly of 1977, found herself in a desolate cattle field, fending entirely for herself among dry weeds and twigs. Without proper feed or veterinary care, the mare became thin, and her once glossy bay coat was dulled by neglect.

Fortunately, Mims's story did not end there. The mare caught the eye of horsewoman Jeanne Mirabito, who instituted measures to restore the aging champion to health. Jeanne eventually gained ownership of Mims, who lived happily under her care for the remainder of her years. In her honor, Jeanne created Our Mims Retirement Haven, a home for retired racing mares in Paris, Kentucky. Thanks to the efforts of Jeanne Mirabito, Our Mims's story had become one for the ages.

By the summer of 1979, key records were continuing to be made at the Spa. General Assembly, a son of Secretariat, romped to a fifteen-length win in the Travers, setting a track record of 2:00 that remains as of this writing. The colt, while somewhat inconsistent on the track, had demonstrated his fondness for the Saratoga track as a juvenile, winning both the Hopeful and the Saratoga Special, and completing the latter six furlongs in a record 1:09.

In preparation for the Travers, General Assembly entered a seven-furlong allowance at the Spa, winning handily. The Travers attracted a strong field, despite the absence of Derby winner Spectacular Bid and Belmont winner Coastal. The entries would include Canadian champion Steady Growth; Smarten, who had won six races at the same number of tracks; and Calumet Farm's champion filly Davona Dale. The filly would

Jeanne Mirabito with Our Mims, 1977 Alabama Stakes champion. *Photo by John Bellucci.*

be sent off as the favorite, despite being handed a surprising loss in the Alabama one week prior.

General Assembly broke early from the inside post, taking a commanding lead in the backstretch and opening up a fifteen-length lead over a sloppy, rain-drenched track. Smarten rallied to finish second, followed by Private Account and the seemingly tired Davona Dale. *Sports Illustrated* praised the colt, stating, "Not since Secretariat himself won the 1973 Belmont Stakes by 31 lengths has there been so overwhelming a triumph in a race of such high significance."[50]

LeRoy Jolley, General Assembly's trainer, later spoke of his horse to the media. "There has been some talk about making the Saratoga meeting longer," he told the throngs of reporters. "As far as General Assembly is concerned, they should make it a year-round meeting."[51]

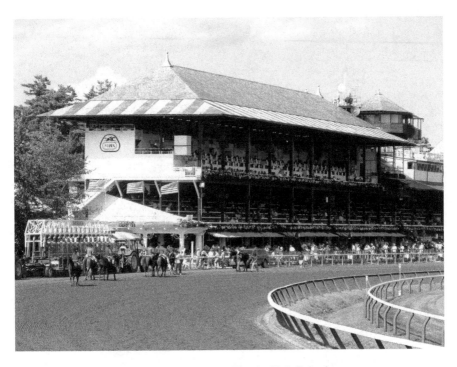

A view of the track and its iconic grandstand. *Photo by Cindy Dulay, horse-races.net.*

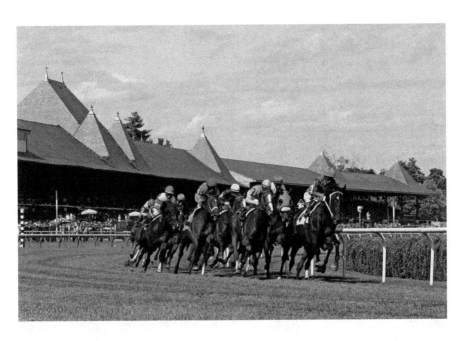

Horses race around the turn on the Saratoga turf. *Photo by Jessie Holmes.*

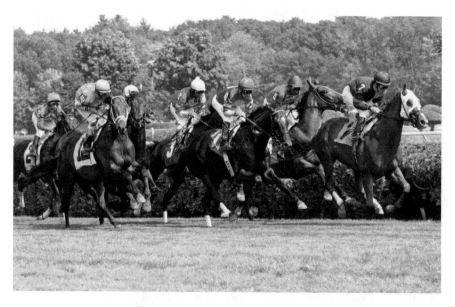

Turf racing on a warm summer's day. *Photo by Jessie Holmes.*

Lawn jockeys greet visitors at the entrance to the racecourse. *Photo by Jason Moran.*

An artist paints a summer scene in the paddock area. *Photo by Jason Moran.*

Kentucky Derby champion Mine That Bird walks behind the statue of Sea Hero. *Photo by Walter Kobbe.*

Left: The Travers canoe in 2010, painted with the colors of Gainesway Farm and Afleet Express. *Photo by Jessie Holmes.*

Below: A horse is led through the scenic paddock area. *Photo by Cindy Dulay, horse-races.net.*

Right: Sunrise on the
Oklahoma training track.
Photo by Jessie Holmes.

Below: A horse gallops in
Saratoga's legendary morning
mist. *Photo by Jessie Holmes.*

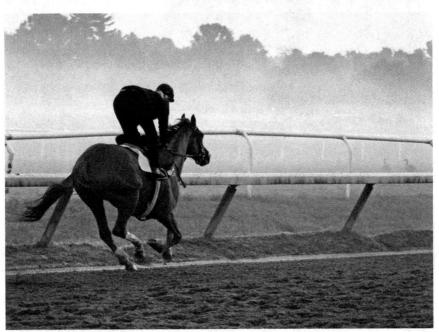

An early morning on the Saratoga backstretch. *Photo by Bud Morton.*

Champion filly Rachel Alexandra is bathed after a workout. *Photo by Jason Moran.*

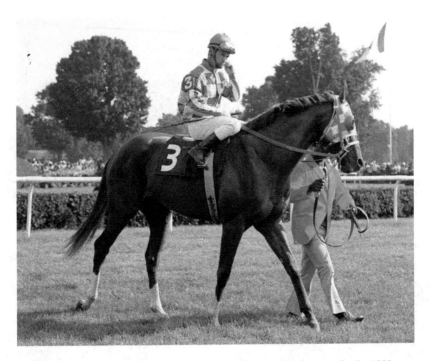

Triple Crown champion Secretariat and jockey Ron Turcotte head to post for the 1973 Whitney. *NYRA photo, courtesy of Adam Coglianese.*

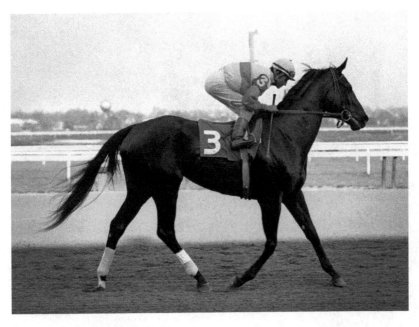

Spinaway Stakes champion Ruffian, shown here at Belmont with jockey Jacinto Vasquez. *NYRA photo, courtesy of Bob and Adam Coglianese.*

Above: Affirmed leads Alydar in the 1978 Travers stakes. *NYRA photo, courtesy of Adam Coglianese.*

Left: The promising Timely Writer, winner of the 1981 Hopeful Stakes. *Photo by John Bellucci.*

Lady's Secret in the post parade for the 1986 Whitney Handicap. *Photo by Bud Morton.*

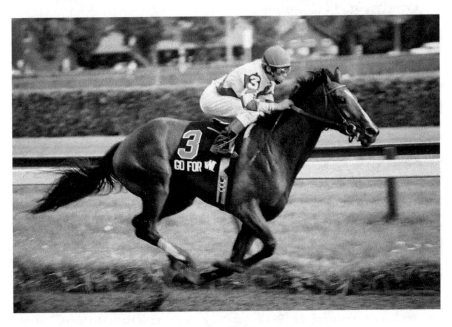

Go for Wand wins the 1990 Alabama Stakes. *Photo by Bud Morton.*

Go for Wand's grave site. *Photo by Jessie Holmes.*

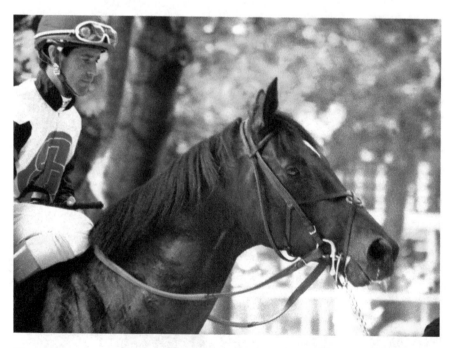

Thunder Rumble, winner of the 1992 Travers Stakes, with jockey Herb McCauley. *Photo by Jason Moran.*

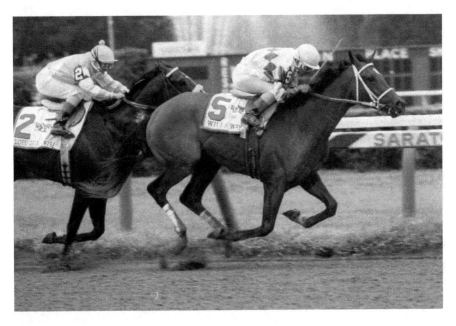

Will's Way wins the 1996 Travers. *Photo by Bud Morton.*

Fan favorite Fourstardave, ridden by the equally popular Angel Cordero Jr. *Photo by Bud Morton.*

Medaglia d'Oro, the first horse to win the combination of the Jim Dandy, Travers and Whitney races. *Photo by Bud Morton.*

Kentucky Derby champions Street Sense and Calvin Borel, winners of the 2007 Jim Dandy and Travers Stakes. *Photo by Jessie Holmes.*

Opposite, top: Lawyer Ron and jockey John Velasquez (right), winners of the 2007 Woodward and Whitney Stakes. *Photo by Jessie Holmes.*

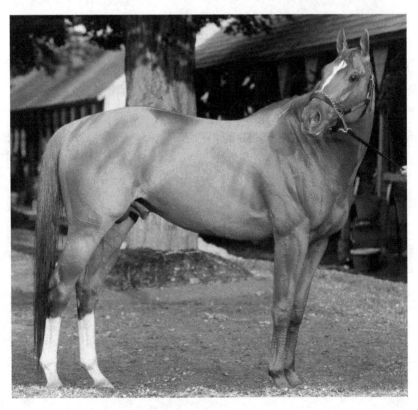

2008 Woodward Stakes champion Curlin poses on the Saratoga backstretch. *Photo by Wendy Uzelac Wooley.*

Left: Ginger Punch, two-time winner of the Go for Wand Handicap, and jockey Rafael Bejarano. *Photo by Jessie Holmes.*

Below: Commentator, two-time Whitney champion, with jockey John Velasquez. *Photo by Jason Moran.*

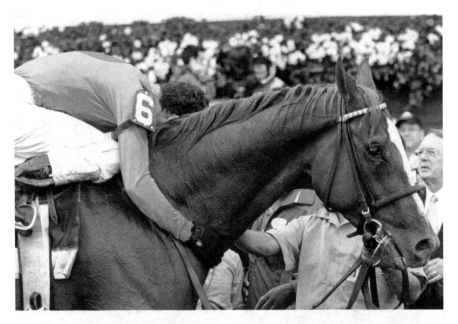

2009 Travers champion Summer Bird and jockey Kent Desormeaux. *Photo by Jessie Holmes.*

Rachel Alexandra battles Life at Ten in the 2010 Personal Ensign Handicap, which was won by Persistently. *Photo by Jessie Holmes.*

Afleet Express and jockey Javier Castellano, winners of the 2010 Travers Stakes.
Photo by Jessie Holmes.

Juvenile champion Uncle Mo in his maiden victory with jockey John Velasquez.
Photo by Jessie Holmes.

Chapter 15

FAN FAVORITES

S ince its inception back in 1903, the Hopeful Stakes had become the premier race for two-year-olds. Its roster of champions was impressive, with a group that included Man o' War, Whirlaway, Native Dancer and Secretariat. In 1981, an unexpected champion would add his name to that illustrious list, earning himself a key place in the hearts of Saratoga race fans.

If talent were correlated with longevity, Timely Writer would have lived to sire many champions. A son of Staff Writer out of the mare Timely Roman, the plain bay colt showed tremendous promise. Timely Writer had an "everyman" quality that reminded folks of Seabiscuit. In addition to his talent, the two-year-old was distinguished by the fact of his humble existence.

Timely Writer was owned by Peter and Francis Martin, two brothers who managed a meatpacking plant in Boston. The Martins owned a string of horses under their Nitram Stable, a name derived from the backward spelling of "Martin." While their stable primarily consisted of claimers, the Martins dreamed of one day finding the proverbial "big horse." They found just that in Timely Writer, who was purchased for a mere $13,500 and began his career in a claiming race at Monmouth Park.

The Staff Writer colt arrived at Saratoga in 1981 under the banner of trainer Dominic Imprescia. His first race at the Spa was the Saratoga Special, where he finished a game third after getting into early trouble. The winner of that race was Conquistador Cielo, who would capture the Belmont Stakes the following year. In contrast to Timely Writer, Conquistador Cielo had been purchased for $150,000 as a yearling.

Timely Writer would return to the track for the much-touted Hopeful Stakes. The favorite was the chestnut gelding Out of Hock, and little attention was paid to the Boston-based long shot. Ridden by jockey Roger Danjean, Timely Writer stalked the pace before roaring from the outside post in the stretch to overtake the favorite. Winning the Hopeful by a solid four lengths, Timely Writer established himself as a legitimate contender. This win, coupled with later victories in the Champagne Stakes and Florida Derby, made Timely Writer a favorite for the Triple Crown. In March 1982, the one-time claimer was the subject of a feature in *Sports Illustrated*.

The following month, rather than preparing for the Derby, Timely Writer was recovering from colic surgery at a veterinary hospital. Given odds of 50-50 merely to survive, he fought back valiantly and returned to training. At Saratoga that summer, he "toyed with a field of four older horses" and won the $32,000 Saratoga Hospital Purse by nearly three lengths.[52] Bolstered by the cheers of adoring fans, he finished the race in 1:21 ⅗ despite little urging from jockey Jeffrey Fell.

After showing great promise in his later races, the colt was pointed toward the Jockey Club Gold Cup at Belmont Park. It was to be his final race before retiring to stud duty, as his breeding rights had been acquired by the famed Dr. William O. Reed. Sadly, it was not to be, as Timely Writer shattered his foreleg during the running of the Gold Cup and was euthanized on the track. He was buried in the infield at Belmont, an honor previously bestowed only to the great Ruffian. While fate prevented him from showing his ability among the greats of the sport, Timely Writer is remembered fondly for the brilliance he showed at Saratoga.

Timely Writer's primary jockey, the Canadian-born Jeff Fell, made history at the 1982 Travers when he rode Runaway Groom to victory. The colt became the only horse to defeat the reigning Kentucky Derby, Preakness Stakes and Belmont Stakes winners in the same race when he bested Gato del Sol, Aloma's Ruler and Conquistador Cielo, respectively, for the Travers crown. The *Times* wrote, "A gray gust from Canada named Runaway Groom blew through the Travers Stakes today and toppled the mighty Conquistador Cielo in one of the most spectacular upsets in the upset-filled history of Saratoga Race Track." Runaway Groom, who trailed the field by fifteen lengths in the early stages of the race, topped Aloma's Ruler by three-quarters of a length to emerge as the victor. The favorite, Conquistador Cielo, finished third, nearly one and a half lengths behind the winner.

Racing in the mid- to late 1980s at Saratoga was characterized by the wins of several outstanding mares. The first of these was Lady's Secret, the

most famous daughter of the great Secretariat. She was nicknamed "The Iron Lady," which suitably described both the color of her coat and her steely determination. Lady's Secret first dazzled Spa crowds in the 1985 Test Stakes. There she defeated the favorite, Mom's Command, by an impressive two lengths. Lady's Secret returned to the track eight days later, besting the bay filly Mrs. Revere by a nose in the Ballerina Stakes.

In the summer of her four-year-old season, Lady's Secret challenged six male competitors in the Whitney Stakes while carrying 119 pounds. The favorite at odds of 13-10, the Iron Lady cruised to victory under jockey Pat Day, winning the race by four and a half lengths in a time of 1:49 ⅘. With this win, she became the first female to earn the Whitney title since Gallorette in 1948. Lady's Secret would win ten of fifteen races that season, earning Horse of the Year honors for her efforts. She also became the first horse, since the grading system was implemented, to win eight graded stakes races in a single season.

Two years later, on August 7, 1988, another four-year-old mare would follow in the Iron Lady's hoofprints when she defeated males to win the Whitney. Undefeated in nine starts, the Phipps-owned Personal Ensign was sent off as the betting favorite under jockey Randy Romero. Held in check for the first five furlongs, the mare gradually took control of the field while turning for home. She ultimately defeated champion sprinter Gulch by one and a half lengths, with the eight-year-old gelding King's Swan finishing another seventeen lengths back.

Personal Ensign would retire at the end of the 1988 season with a perfect record of 13-0. In 1997, the one-and-a-quarter-mile John A. Morris Handicap would be renamed in the great mare's honor. The race, for fillies and mares ages three years and older, had originated in 1948 as the Firenze Handicap. Previously run at Jamaica, Aqueduct and Belmont Park, the race was moved to Saratoga in 1986.

The string of victories by females continued in 1990 when the bay filly Go for Wand took center stage at the Spa. Go for Wand took control of the track, winning both the Test Stakes and the Alabama in commanding fashion. Entering the Test Stakes on August 2 after a seven-week layoff, Go for Wand reeled off an impressive two-length victory. She logged seven furlongs in a final time of 1:21.09, carrying top weight of 124 pounds. Nine days later she returned to the track, winning the one-and-a-quarter-mile Alabama Stakes wire to wire over Charon in a speedy 2:00.80. As of this writing, that record has yet to be broken.

Go for Wand died tragically in October 1990 due to an injury sustained while dueling with rival Bayakoa in the Breeders' Cup Distaff at Belmont

Park. At the suggestion of her owner, Jane DuPont Lunger, the decision was made to bury her at the site of her dazzling summer triumphs. Lunger told reporters, "I selected Saratoga. She won two of her biggest stakes there. And Mr. Lunger and I started our racing stable there. It was hard to go back to Saratoga, but it was the right thing to do." In a unique honor befitting the great champion, Go for Wand was buried near the infield flagpole facing the winner's circle. To date, Go for Wand remains the only horse interred in that location. Steven Crist of the *Times* wrote, "The gesture was perfect. No filly in 127 years of Saratoga has dominated that meeting the way Go for Wand did this past August."

As a tribute to the champion filly, the Maskette Stakes at Belmont Park was renamed the Go for Wand Handicap. The race would be moved to Saratoga in 1994; its inaugural running at the Spa would be won by Sky Beauty, whose victories had included the 1993 Alabama Stakes.

The 1993 Travers was particularly memorable, characterized by the comeback win of Kentucky Derby champion Sea Hero. The horse, owned by Paul Mellon, had proven to be somewhat of an enigma to racing fans. After winning the Derby on racing's grandest stage, the colt's winning form had taken a downward turn, and he placed a disappointing fifth in the Preakness and seventh in the Belmont Stakes. At Saratoga in the Jim Dandy just three weeks prior to the Travers, the Derby winner had managed only a fourth-place finish.

A crowd of 46,560 was on hand for the Travers, and Sea Hero did not disappoint his fans. Despite an early brush with eventual third-place finisher Miner's Mark, Sea Hero cruised to a two-length victory over Kissin Kris and Belmont winner Colonial Affair, who placed fourth. In a thrill for owner Paul Mellon, then eighty-six years old, and trainer MacKenzie Miller, age seventy-one, Sea Hero became the first Kentucky Derby champion to win the Travers in a span of fifty-one years.

In commemoration of Sea Hero's win, Mellon commissioned a statue of the champion that now stands proudly in the Saratoga paddock. A noted sportsman and philanthropist, Mellon was an important ambassador to Saratoga racing and contributed much to its development. For his efforts, he would be named "Exemplar of Racing" by the National Racing Museum and Hall of Fame, and one of the turf courses at the Spa now bears the Mellon name.

While flat racing at Saratoga continued to thrive, steeplechase racing also drew large crowds. The New York Turf Writers' Cup, inaugurated in 1938 at the Spa, was a perennial fan favorite. In 1995, the race was won by U.S.

Fan Favorites

Right: Statue of 1993 Travers winner Sea Hero in the paddock area. *Photo by Jessie Holmes.*

Below: Steeplechase champion Lonesome Glory, winner of the 1995 New York Turf Writers' Cup. *Photo by Bud Morton.*

steeplechasing's greatest star, a chestnut gelding called Lonesome Glory. Originally trained as a hunter for owner Kay Jeffords, Lonesome Glory had proved too feisty for the show ring. Steeplechasing was his true calling, and he would rank among the sport's most celebrated champions.

Facing defeat in only two of his U.S. starts and earning in excess of $1.4 million, Lonesome Glory would become the all-time leading money earner in steeplechase history. He would become one of a select group of horses to win five Eclipse Awards, ranking alongside thoroughbred immortals Secretariat, Affirmed, Forego and John Henry. A bronze statue of Lonesome Glory now stands at the National Museum of Racing and Hall of Fame, a reminder of his great contribution to horse racing history.

Chapter 16

SARATOGA'S OLD FRIENDS

W ill's Way was an unlikely choice to don the 1996 Travers crown. In the illustrious history of the "Midsummer Derby," it had gathered an impressive list of winners. Many of the three-year-olds who had won the Travers had long and notable credentials. Two of its three most recent victors at this time (Sea Hero in 1993 and Thunder Gulch in 1995) had prevailed on the biggest stage of all, winning the prestigious Kentucky Derby at Churchill Downs.

It was not that Will's Way lacked the talent; that was never a question in the least. But his career thus far had been marred by setbacks that kept him away from the biggest races. Bucked shins had prevented him from racing as a juvenile, and a pulled muscle kept him home on the first Saturday in May. In all, the bay colt by 1989 Travers champion Easy Goer had made it to the track only five times that season. Heading into the Travers, Will's Way had not even won a stakes race.

Despite such seemingly hefty odds, Will's Way's trainer (who carried the legendary name of James Bond) believed in the colt's potential. After the horse, recovering from injury, missed all three of the fabled Triple Crown races, Bond made a promise to Will's Way's owners. "We won't make the Kentucky Derby," he said, "but I'll make the summer Derby for you, and we'll get it."[53]

Travers and Whitney champion Will's Way in his paddock at Old Friends. *Photo by Rick Capone.*

In the Jim Dandy Stakes, just weeks prior to the Travers, Will's Way put himself on the racing map with a key second-place finish behind Preakness champion Louis Quatorze. The Preakness winner would be sent off at betting odds of 2-1 in the Travers, with the gray colt Skip Away the heavy favorite. Belmont winner Editor's Note was also included in the field of seven colts on August 24.

Heading into the Travers Stakes, Bond gave instructions to jockey Jorge Chavez to bide his time and not give in to early speed. The plan worked, and as the early leaders tired with a quarter mile to go, Will's Way made his daring move. As applause thundered through the grandstand, Will's Way outdueled Louis Quatorze by a quarter of a length, finishing the race in 2:02 ⅖ and paying $16.60 for a $2.00 bet to win. Skip Away finished third, two lengths behind the winner, while Editor's Note finished four lengths back. The *Times* took note of Will's Way's win, issuing in bold letters, "SARATOGA SURPRISE: WILL'S WAY CAPTURES TRAVERS."

Returning to the Spa the following summer, Will's Way proved that his Travers win was no fluke. He prevailed in the Whitney by a nose over Formal Gold, a son of Black Tie Affair, with Skip Away once again finishing third. Trainer Bond said of Will's Way, "For a lightly raced horse, he's very professional. Basically, he's a prince."

Hidden Lake, winner of the Go for Wand Handicap, poses in her paddock. *Photo by Rick Capone.*

While Will's Way proved his mettle in the Whitney, a four-year-old mare named Hidden Lake also impressed race-goers at the Spa. She was the favorite heading into the recently renamed Go for Wand Stakes, sent off at betting odds of 3-5. The bay daughter of Quiet American was known for galloping off the pace, with a front runner clearly visible. In this race, however, the mare broke first, and jockey Richard Migliore allowed her to take the lead. At the half mile, the pair was challenged by Flat Fleet Feet, and a speed duel ensued. When the younger filly took the lead heading into the final sixteenth, Hidden Lake gave it her all. Battling with every ounce of her strength, the mare finished first and collapsed beyond the wire of dehydration.

Migliore counted this win among the greatest of his career. "From the recesses of her heart, Hidden Lake found a way to fight back and win," he told the press. "After the finish line, she actually collapsed from exhaustion. That was how much effort she put into winning that race. She was running on empty and found more to give."[54]

Hidden Lake recovered well and returned to racing, winning the Beldame Stakes at Belmont Park that autumn. At the end of the season, she was named champion older female.

Will's Way and Hidden Lake would be among the great champions to live out their years at Old Friends thoroughbred retirement farm. Also among

Travers champion Thunder Rumble rears up in his paddock at Old Friends. *Photo by Connie Bush.*

them would be Thunder Rumble, Kiri's Clown and Awad, who left their own marks on Saratoga racing in the 1990s.

Thunder Rumble was one of the superstars of the 1992 Saratoga season when he reeled off wins in both the Jim Dandy and the Travers. Three weeks after his win in the Jim Dandy, a crowd of more than forty-six thousand fans watched the dark son of Thunder Puddles capture the Travers over multiple stakes winner Devil His Due. The victory marked the first time in the twentieth century that a New York–bred won the Travers Stakes. On hand for the win was Governor Mario Cuomo, who, according to the *Times*, "not only paid his first visit to a New York race track in nine years but also announced that he was betting on the homebred, Thunder Rumble."

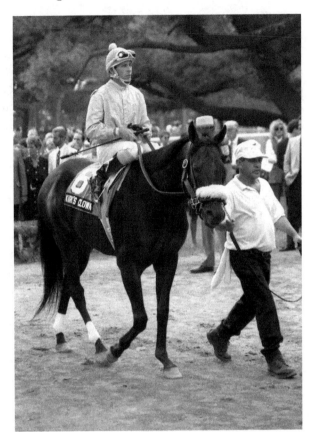

Right: Kiri's Clown, winner of the 1995 Sword Dancer Invitational. *Photo by Jason Moran.*

Below: Sword Dancer champion Kiri's Clown struts for the camera. *Photo by Rick Capone.*

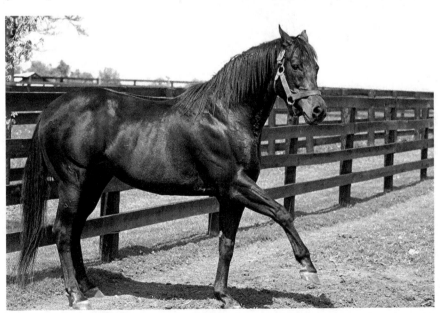

Three years after Thunder Rumble's historic win, Kiri's Clown garnered attention when he won the Sword Dancer Invitational Handicap in 2:25.45, setting a new record for one and a half miles on the Spa's turf course. A son of Kentucky Derby champion Foolish Pleasure, Kiri's Clown had placed second in the Sword Dancer the previous year and would repeat that finish in 1996. The Sword Dancer, inaugurated in 1975 at Aqueduct, had moved to Saratoga in 1992 after a fifteen-year stint at Belmont Park. The race was named in honor of the chestnut stallion Sword Dancer, the 1959 Travers winner and Horse of the Year.

Two years later, on August 10, 1997, the colt Awad would best his future Old Friends neighbor's record, winning the Sword Dancer in a blistering 2:23.20. Awad achieved this feat while racing over nine distance-running speedsters, including Influent, whom the *Times* had called "the hottest horse in the East." It was another surprising win at the Spa, as the seven-year-old Awad had won only one of his last seventeen starts. Ridden by Pat Day, Awad sat back early as Winsox, a son of Deputed Testimony, set a blazingly fast pace. The charging Influent then took command, running three-quarters of a mile in 1:09 ⅘. As the leaders tired on the straightaway, however, Awad unleashed his power, crossing the wire two lengths ahead of the Brazilian-owned Fahim. Influent, the

Awad, winner of the 1997 Sword Dancer Invitational. *Photo by Rick Capone.*

heavily favored leader, faded to fifth, becoming another casualty of the graveyard of champions.

It was around this time that a New York–bred named Fourstardave established a lifelong connection with Saratoga. After winning the Empire Stakes with little fanfare as a two-year-old in 1987, he would go on to win at least one race at Saratoga every year for eight years, excelling on both dirt and turf. The chestnut gelding caused a sensation at the Spa, where fans dubbed him the "Sultan of Saratoga" and followed his every move. Fourstardave became a goodwill ambassador at the Spa, where fans hosted parties in his honor, donned T-shirts and caps bearing his name and cheered wildly from the sidelines each time he made his way to the track. The entire town of Saratoga Springs caught on, naming a small street in the horse's honor and presenting the animal with an edible "key to the city." The *Blood-Horse* would write of Fourstardave, "Although he captured 13 stakes in his career and placed in 23 others, he gained his fame at Saratoga, where each victory added to his popularity. As he grew older and extended his consecutive-win record, he became a folk hero, as fans at the Spa cheered wildly each time he set foot on the racetrack."[55]

When Fourstardave passed away in 2002, there was little questioning that he should be buried at Saratoga. He was interred in the bucolic Clare Court area, which also serves as the resting place of two other horses, Irish-bred turf runner Mourjane and Jim Dandy winner A Phenomenon. The Sultan of Saratoga lives on at the Spa, as a race named in his honor is run annually on the Saratoga turf. The Fourstardave Handicap is a one-and-a-sixteenth-mile grade-two race open to older males.

While Fourstardave was commonly referred to as the "Sultan of Saratoga," jockey Angel Cordero Jr. was known as the "King." Cordero won eleven consecutive riding titles at the Spa from 1976 to 1986, gaining two additional titles in 1988 and 1989. A native of Puerto Rico, Cordero had followed in the career path of his father, who was a successful jockey and trainer.

Cordero won his first race in his native country in 1960 before beginning a successful career in the United States. Counted among his numerous victories are three Kentucky Derbys, two Preakness Stakes and one Belmont Stakes. When Cordero retired in 1992, NYRA designated August 30 as "Angel Cordero Day" at the Spa, and several festivities were held in his honor. In response to this tribute, Cordero stated, "Saratoga is the place. To race there is a privilege. It's like going to the World Series."[56]

Saratoga's prominence in the overall sports world was once again recognized in 1999, when *Sports Illustrated* named the racecourse among the

ten greatest sports venues of the twentieth century. Saratoga was the only racing venue named on the elite list, which also included famed Yankee Stadium and Lambeau Field. In an article listing the top twenty choices, *Sports Illustrated* summarized the essence of Saratoga: "With its striped awnings, old wooden clubhouse and grandstand, and paddock shaded by elms, Saratoga transports you back to the days when people came to the races in surreys with the fringe on top."[57]

Chapter 17

THE NEW MILLENNIUM

A s the year 2000 ushered in a new century, Saratoga racing continued at the highest level. In 2001, the Travers drew its largest crowd of 60,486 spectators and generated bets of $34,529,273. The race was won by Preakness and Belmont Stakes champion Point Given in a triumphant victory over a field of eight other starters. With this win, Point Given not only secured Horse of the Year honors but also became the first horse since Damascus in 1967 to win the Preakness, Belmont and Travers combination—joining an elite group that also included Man o' War, Whirlaway and Native Dancer.

Point Given's jockey, Gary Stevens, would return to Saratoga the following year when filming of the movie *Seabiscuit* began at the track. The film, which was also staged at Keeneland in Kentucky, was based on Laura Hillenbrand's bestselling novel, *Seabiscuit: An American Legend*. In his first acting role, Stevens starred as famed jockey George Woolf opposite Tobey Maguire as "Red" Pollard. The film's release in 2003 would bring a slew of new visitors to both the racecourse and the National Racing Museum, as fans sought out Seabiscuit-related information and artifacts.

A key winner during the early 2000s was the colt Medaglia d'Oro, whose Italian name translates in English to "gold medal." He arrived at Saratoga as a three-year-old in 2002, having recently placed second in the Belmont Stakes. Medaglia d'Oro had an impressive wire-to-wire win in the Jim Dandy with jockey Jerry Bailey in the saddle, garnering a Beyer speed figure (a calculation of performance in an individual race) of 120, the highest for a three-year-old that season. He capped off that victory

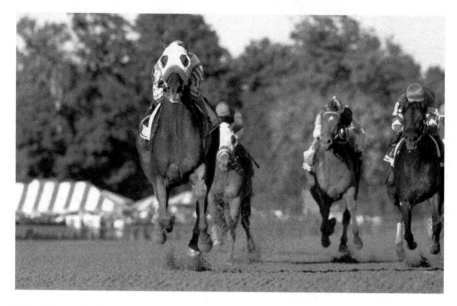

Point Given wins the 2001 Travers with jockey Gary Stevens. *Photo by Bud Morton.*

with a commanding win in the Travers, where he defeated Louisiana Derby winner Repent.

Medaglia d'Oro returned to the Spa the following year, where he solidified his reputation with a victory in the Whitney. He thus became the only horse in Saratoga's history to win the Jim Dandy, Travers and Whitney Stakes. Retiring after a stellar career that also included a win in the Donn Handicap at the age of five, Medaglia d'Oro began stallion duty. His first crop, foaled in 2006, produced a dark bay filly by the name of Rachel Alexandra, who would soon be making history of her own.

In 2003, New York racing experienced a surge of excitement when the state-bred Funny Cide won the Kentucky Derby and Preakness Stakes. Sired by Distorted Humor, Funny Cide was nicknamed "The Pride of New York" for his birthplace and "The People's Horse" for his accessibility to the public. Funny Cide would finish in the money in several races at Saratoga, including placing second in the 2004 Saratoga Cup behind two-time winner Evening Attire. By the time of his retirement in 2007, Funny Cide had earned $3,529,412, leading all New York–bred racehorses. NYRA hosted a retirement party at Saratoga in his honor, during which he was paraded through the paddock area, allowing fans to gain a close-up look at their star. In 2009, Saratoga inaugurated the Funny Cide Stakes, a race for older New York–bred horses run at one and one-eighth mile.

Above: Evening Attire (left), winner of the Saratoga Cup in 2002 and 2004. *Photo by Bud Morton.*

Right: Saratoga crowd favorite Funny Cide, winner of the 2003 Kentucky Derby and Preakness Stakes. *Photo by Bud Morton.*

Funny Cide was not the only New York–bred to command attention at the Spa in this decade. On August 5, 2005, the four-year-old chestnut gelding Commentator (also by Distorted Humor) defeated the multiple stakes winner Saint Liam to capture the Whitney before a crowd of 32,287 fans. Commentator led wire to-wire, thwarting a threat by Saint Liam, who would later win the Breeders' Cup Classic and secure Horse of the Year honors. Commentator won his second Whitney on July 26, 2008, by nearly five lengths, earning a Beyer speed figure of 120 for the victory. Commentator was the second-oldest horse (ranking only behind the eight-year-old Kelso) to win the Whitney and one of only three horses to win multiple runnings of the race.

Commentator was named New York Horse of the Year in both 2007 and 2008. The following year, he returned to Saratoga for an attempt at his third Whitney victory. In a game effort, he ultimately placed third. On September 6, 2009, the NYRA honored Commentator in a special ceremony at Saratoga. That day's fifth race, an overnight stakes race for New York–bred three-year-olds and older, was dubbed "The Commentator."

The summer of 2006 was characterized by a wave of blistering heat. This resulted in the closure of the racecourse on August 2, 2006, marking only the fourth time in the history of the track in which it was closed. That same year, the Woodward Stakes, named for William Woodward Sr., was moved from Belmont Park to Saratoga. Currently run at a distance of one and an eighth miles, the

Two-time Whitney champion Commentator at Old Friends. *Photo by Rick Capone.*

Woodward is open to horses three years old and up and has become a showcase of the nation's greatest champions, including, among others, Kelso, Damascus, Buckpasser and Spectacular Bid. Forego won four consecutive runnings of the race, setting a speed record of 1:45.80 in his third victory in 1976. Incidentally, when Forego made an appearance at the Spa in 1977, he drew a crowd of twenty-nine thousand who braved heavy rain "just to wish him well."[58]

A four-time winner of the Woodward Stakes, Forego drew enormous crowds when he made an appearance at the Spa. He is shown here in later years. *Photo by John Bellucci.*

The initial running of the Woodward at Saratoga was a thrilling one, with the victory of 30-1 long shot Premium Tap, ridden by jockey Kent Desormeaux. Sun King and Flower Alley were the co-favorites at 5-2 in the field of ten that also included Funny Cide. Desormeaux set the early pace aboard Premium Tap, battling for position with fellow long shot Second of June. As Funny Cide loomed in third, Premium Tap opened up on the turn for home, overtaking Second of June and the fast-approaching Sun King. In the end, Premium Tap prevailed with a full length over Second of June. The second running of the Woodward at the Spa was equally enthralling, as Lawyer Ron reeled off an eight-and-a-quarter-length win. Piloted by John Velasquez, the chestnut colt also dominated in the Whitney, setting a speed record at a time of 1:46.64 for one and an eighth miles.

The year 2007 was another great one for racing, and all eyes were on four-year-old mare Ginger Punch as she captured her first grade-one win in the Go for Wand Handicap. The Bobby Frankel–trained mare had won her first

Premium Tap and jockey Kent Desormeaux, winners of the 2006 Woodward Stakes. *Photo by Bud Morton.*

stakes race just weeks before, galloping to victory in the seven-furlong First Flight Handicap by open lengths at Belmont. At Saratoga, however, she would be running over two additional furlongs. While the additional distance had caused some concern for Frankel, the mare drew away from the field at the top of the stretch, winning by six lengths in 1:49. With this victory, Ginger Punch earned a spot in the Breeders' Cup Distaff at Monmouth Park, which she won handily over a muddy track. By 2008, Ginger Punch had logged an impressive race record, placing first or second in the majority of her starts.

On July 26, 2008, Ginger Punch won her second consecutive Go for Wand, joining an elite club of mares that have won the race more than once. It was a hard-earned victory for the chestnut mare, as she had been boxed in on the inside for much of the race. Displaying the championship form that had long dazzled her fans, the daughter of Awesome Again split the field nearing the end of the race, ultimately taking the win by one and a quarter lengths over Copper State.

Another key winner at this time was Kentucky Derby champion Street Sense, who prevailed in the 2007 Jim Dandy and Travers Stakes. After Street Sense narrowly lost the Preakness Stakes to the late-charging Curlin, owner James Tafel had opted to skip the Belmont, turning his attention instead to Saratoga's summer card. The reigning Derby champion drew a crowd of 46,876 for his inaugural Saratoga romp on July 29. Ridden by the fan favorite Calvin Borel,

2008 Woodward Stakes champion Curlin with jockey Robby Albarado. *Photo by Jason Moran.*

Street Sense did not disappoint, as he won the Jim Dandy by one and a quarter lengths over the Nick Zito trainee C.P. West. Cheers resonated loudly from the grandstand as the dark bay son of Street Cry was led to the winner's circle.

Street Sense returned to the track on August 25, winning an inspiring run of the Travers over the fast-running Grasshopper. The two colts dueled in a fierce stretch run, with the Derby champion besting his foe on the outside by a gritty half length. With this win, Street Sense became the first horse in twelve years to win the Kentucky Derby and Travers combination of races. Thunder Gulch in 1995 had been the last to win that duo of races.

Street Sense's Preakness foil, the chestnut colt Curlin, made his first appearance over the Spa's hallowed track in the summer of 2008. The reigning Horse of the Year, Curlin was coming off five straight wins on dirt as he took to the post in the Woodward Stakes. Sent off as the 1-4 favorite, Curlin overcame a difficult outing to overtake long shot Past the Point to win by one and a quarter lengths under jockey Robby Albarado. After being bumped near the first turn and being forced wide, Curlin showed his brilliance by making up nearly ten lengths in the last three furlongs. This turn of events had caused some concern for trainer Steve Asmussen, who later noted, "The mystique of Saratoga—the Graveyard of Champions—all that works on your head leading into this."[59]

2008 Travers winner Colonel John with jockey Garrett Gomez. *Photo by Jessie Holmes.*

With his win in the Woodward, Curlin overtook Skip Away as the second-leading money winner in history. Following a subsequent win in the Jockey Club Gold Cup at Belmont, Curlin became the all-time North American money earner and the only runner to have earned more than $10 million. At season's end, he earned his second straight Horse of the Year title. In his honor, Saratoga established the Curlin Handicap, a one-and-an-eighth-mile race for three-year-olds on the dirt.

The 2008 season ended on a high note when Colonel John narrowly defeated Mambo in Seattle in the Travers after a long stretch duel. In fact, the finish had been so close that jockey Robby Albarado (aboard Mambo in Seattle) pumped his fist in triumph after crossing the wire. But it was the son of Tiznow, Colonel John, who had earned the coveted Man o' War trophy.

The race had been eventful from the start. Colonel John, distracted by crowd noise, had a difficult break and was boxed in early in the field of twelve starters, the largest Travers field since 1990. Jockey Garrett Gomez settled the colt, whose abilities on dirt had been questioned after his disappointing sixth-place finish in the Kentucky Derby. But the horse

showed winning form over the Saratoga track. Colonel John broke from the pack inside the eighth pole, where a duel began with the outside-running Mambo in Seattle. The two colts dueled ferociously to the wire, with Colonel John prevailing by a slight bob of the head. Colonel John's owner, Bill Casner, summed up the history of the midsummer derby when he spoke to the press after the race. "The Travers is certainly the second-most prestigious three-year-old race next to the Kentucky Derby," he told the press. "It is a race for the ages."[60]

Chapter 18

RACHEL AND BEYOND

A s the last breaths of springtime faded into summer, the racecourse came alive with talk of a new champion. The buzz grew louder heading into August. Banners in various shades of pink lined the streets in downtown Saratoga Springs, and race-goers donned buttons bearing the name "Rachel." Fans waited for hours in the sweltering heat to catch a glimpse of one special horse. It was August 2009 at Saratoga, and "Rachel-mania" was in full swing. "She's been called a rock star," said a news reporter for WNYT. "And she gets rock star treatment when she comes to Saratoga Race Course."[61]

The fanfare was directed at Rachel Alexandra, a dark bay three-year-old filly with distinctive white facial markings. In the spring she had made history at Churchill Downs with an unprecedented 20¼-length victory in the historic Kentucky Oaks. She followed that win with a triumph in the Preakness Stakes, where she thwarted a late charge by the reigning Derby winner, Mine That Bird. Rachel Alexandra became the first filly to win the Preakness since Nellie Morse in 1924.

Following her Preakness win, Rachel shipped to Belmont Park, where she won the Mother Goose Stakes by nineteen and a quarter lengths, breaking the stakes record with a time of 1:46.33. This win also surpassed the margin of victory of thirteen and a half lengths that had been set by the immortal Ruffian in 1975, prompting comparisons between the two fillies. Rachel then headed to Monmouth Park for the Haskell Invitational, becoming only the second filly in history to win this race. Rachel achieved a Beyer speed

2009 Horse of the Year Rachel Alexandra breezes at Saratoga. *Photo by Connie Bush.*

rating of 116 for this victory, the highest of any horse in North America that season. At the Spa on September 5, the "super filly" continued her domination, as she held off a late charge by Macho Again to become the first female ever to win the Woodward. With that victory, she became the first three-year-old filly since 1887 to win a grade-one dirt race against older males. It was the ninth consecutive win for Rachel Alexandra, who capped off the season by being named Horse of the Year.

Rachel returned to the Spa in August 2010, where she was unable to catch the Phipps-bred Persistently, who bested Rachel by one length in the Personal Ensign Stakes. It was to be Rachel's last race, as she was subsequently retired for broodmare duty at season's end. Prior to her retirement, Rachel continued to amaze Spa crowds, posting a bullet workout of four furlongs in 0:48.45 on the Oklahoma training track on September 27.

In the same season in which Rachel Alexandra captured the Woodward, a chestnut colt named Summer Bird prevailed in the Travers Stakes.

Summer Bird had won the Belmont Stakes that season and had placed second behind Rachel Alexandra in the Haskell Invitational. While he would not face Rachel this time out, Summer Bird's competitors would include the talented Quality Road, a bay colt who had set track records while winning the Florida Derby and Amsterdam Stakes. Also entered was Kensei, winner of the 2009 Jim Dandy Stakes. Over a sloppy track drenched from morning rain, Summer Bird took the lead over Kensei at the quarter pole. Demonstrating his raw power on the final stretch, the son of Birdstone held off a late charge by long shot Hold Me Back to win the Travers in 2:02.83.

With this win, Summer Bird repeated a precedent set by his sire, who had won both the Belmont and Travers in 2004. Birdstone was owned by Marylou Whitney (widow of Cornelius Vanderbilt Whitney), a

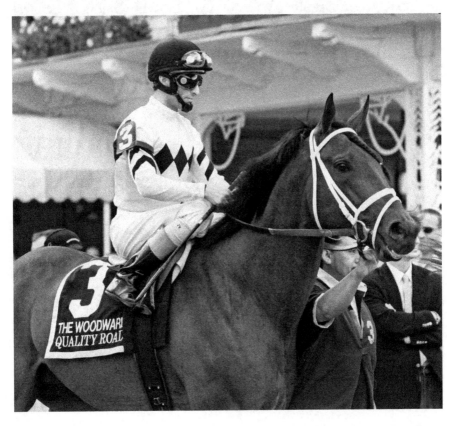

2010 Woodward Stakes champion Quality Road and jockey John Velasquez. *Photo by Jessie Holmes.*

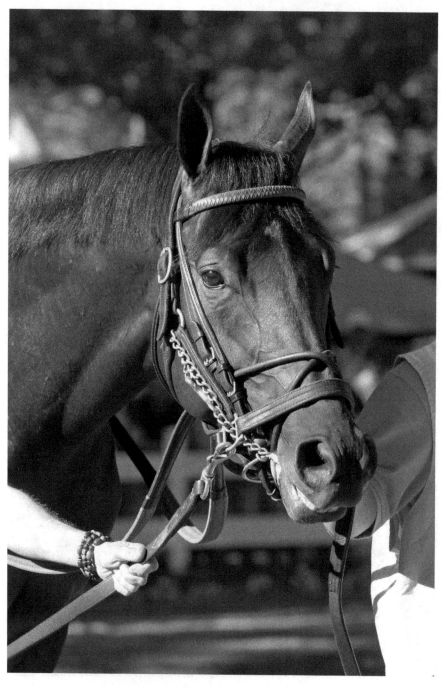

Blame, winner of the 2010 Whitney Handicap. *Photo by Jessie Holmes.*

much-admired figure at the racecourse. Mrs. Whitney has been widely recognized for her many philanthropic efforts at Saratoga, as well as the racing industry as a whole. She hosts an annual gala each year and founded an appreciation program to benefit backstretch workers at the racecourse. Among her many other accomplishments, Mrs. Whitney was a founding member of the Thoroughbred Retirement Foundation. In 2010, she received one of the highest honors in the thoroughbred racing industry, the Eclipse Award of Merit. In addition to this honor, she received a citation from New York's Governor Andrew Cuomo proclaiming her "Queen of Saratoga."

The aforementioned Quality Road had a memorable season at the Spa in 2010, winning the Woodward Stakes by four and three-quarter lengths over Peachtree Stable's Mythical Power. Weeks earlier, he was bested by a head in the Whitney in an exciting finish duel with Claiborne Farm's four-year-old stallion, Blame. In winning the Whitney, Blame secured older horse championship honors. The 2010 Travers ended in spectacular fashion, with the photo finish victory of Afleet Express over Fly Down by the narrowest of margins. Race-goers also continued to look toward the future as the Spa served as the starting ground for the stars of tomorrow. One such horse, the talented juvenile colt Uncle Mo, broke his maiden by fourteen and a quarter lengths on August 28, 2010, en route to capturing champion two-year-old colt honors for the season.

There is an old adage that states, "The more things change, the more they stay the same." That motto could be used to describe the great Saratoga Race Course. Through its long and illustrious history, the racecourse has retained its splendid Old World charm. Horses continue to be paraded through the paddocks, where fans can gain an up-close look at their equine stars against the scenic background of emerald grass and pillow-like Saratoga clouds. The lovely aged elm trees provide ample shading, and the bell that once called the jockeys to their posts continues to ring as it did so long ago. The unique grandstand, with its pyramidal roof and ebullient red-and-white awnings, reminds us of a better time. And during a walk along its grounds, one can almost feel the presence of greatness.

The talented Joe Palmer wrote long ago:

> *Saratoga represents a reaffirmation of racing as enjoyment, of the original forces which first called it into being. You come away feeling that, well, there is going to be a good deal of concrete and gravel in your horoscope for a goodish while, but afterward there will be Saratoga again, with its shaded*

paddocks…I rather think that the charm of Saratoga is that it represents to those to whom racing is a way of life, something to which they may at need return. It is, of course, the oldest track in America, and its ways are old-fashioned ways. After eleven months of new-fashioned ways, it is as restful as old slippers, as quiet as real joy.[62]

Afterword

HISTORY OF THE NATIONAL
MUSEUM OF RACING

L ed by Cornelius Vanderbilt Whitney, a group of people prominent in racing established the National Museum of Racing in Saratoga Springs, New York, in 1950. Less than a year later, on August 6, 1951, amid a great deal of fanfare, the museum opened in a temporary location at the Canfield Casino in Congress Park.

"The long-range purpose," Whitney said at the opening in the famous old casino, "is to build a permanent home for the important memorabilia for the sport whose beginnings in this country antedate by 100 years or more the United States of America."

Four years later, the museum moved to a newly constructed facility at 191 Union Avenue, directly across the street from historic Saratoga Race Course. Through the decades, the museum has grown in size and scope and occupies a sprawling building with some forty-five thousand square feet of space.

The museum was built at the corner of Union Avenue and Ludlow Street on a section of a lot first developed in 1894 by Joseph J. Gleason, a famous bookmaker of the time. Known as "One, two, three Gleason," he is credited with being the first man to lay odds against horses being first, second or third. The huge house with a wraparound porch located at 193 Union Avenue was later owned by Samuel Rosoff, often called "Subway Sam" because his company built some of the subways in New York City. A *New York Times* article about Gleason said his house was built to rival the place built by Charles Reed, then proprietor of the Saratoga Club.

Joining Whitney as the founding group who signed the charter for the museum were George D. Widener, F. Skiddy von Stade, Donald P. Ross, Kenneth K. Burke, Nelson Dunstan, John Hay Whitney, Carlton F. Burke and John C. Clark. Also recognized as organizers of the museum are Walter M. Jeffords, Francis Dorsey, Howell E. Jackson, Paul Kerr, Denis Mansfield, Dr. Charles Strub, Bryce Wing, Spencer Eddy, Saratoga Springs mayor Addison Mallery and Robert F. Kelley.

The first gift for the museum project was $5,000 from the Saratoga Association, which owned and operated Saratoga Race Course. Harold O. Vosburgh, a steward for the Saratoga Association, donated the first piece of memorabilia, a shoe from the horse Kentucky, winner of the first running of the Travers Stakes in 1864. Dunstan, the president of the New York Turf Writers Association, donated a swagger stick owned by jockey "Winnie" O'Connor, who was elected to the Hall of Fame in 1956.

Whitney served as the first president of the museum from 1950 to 1953. He was followed by Jeffords, 1953–60; Widener, 1960–68; John W. Hanes, 1968–70; Gerard S. Smith, 1970–74; Charles E. Mather II, 1974–82; Whitney Tower, 1982–89; John T. von Stade, 1989–2005; and Stella F. Thayer, 2005 to the present.

The museum was popular from the beginning. During its first year of operation at the Canfield Casino in 1951, the museum attracted more than 8,000 visitors. At the end of 1952, the museum register showed 11,500 names.

In September 1953, the house at 193 Union Avenue and the lawns and gardens that stretched to Ludlow Street to the west were purchased by Mrs. Eva Fitzgerald, who turned the residence into a guest home. One year later, Mrs. Fitzgerald sold the piece of the property closest to Ludlow Street, with 160 feet of frontage on Union, to Jeffords. Newspaper reports said the property was purchased by the Saratoga Association and donated to the museum. The deed on file shows that Jeffords transferred the property to the museum for one dollar.

Ground was broken for the project during the final week of November 1954. The cornerstone was laid in April 1955, and New York governor W. Averell Harriman presided over the formal dedication on August 16, during the Saratoga racing season.

Harriman spoke briefly prior to the ribbon-cutting ceremony. "Racing, in order to continue, must remain as a sport," he said, "and not as a commercial enterprise. We must maintain the traditions of racing, and Saratoga is rich in such traditions."

The *New York Times* report on the dedication said the building cost $300,000. The *Times* said that Harriman was greeted at the museum by Ashley Trimble

History of the National Museum of Racing

Cole, chairman of the State Racing Commission; William C. Langley, a member of the commission; Widener, the chairman of the Jockey Club; Burke of the Thoroughbred Racing Association; and Max Hirsch, representing the American Trainers Association. Also in the welcoming group were Eddie Arcaro and Ted Atkinson, representing the Jockeys' Guild; Wing, of the National Steeplechase and Hunt Association; A.B. Hancock of the American Breeders' Association; Sol Rutchick of the Horsemen's Benevolent and Protective Association; and Christopher T. Chenery of the Greater New York Association, which became the New York Racing Association.

Also, the *New York Times* story said that later in the day Harriman became the first New York governor to attend races in the state in more than a dozen years. Harriman was no stranger to racing; he was a former member of the Jockey Club and had operated a racing stable.

The National Museum of Racing opened to the public on June 2, 1956. The building was designed by New York City architect Auguste Noel. In 1957, the first addition, called the Patrons of the Turf Gallery, was completed. More expansion followed. A third wing was added in 1979 and became the home of the Hall of Fame.

In 1966, the museum purchased the property at 193 Union Avenue from the Fitzgerald family. The house, built from the fortune Gleason earned as a bookmaker, featuring the porch where Rosoff held court before and after the races, was torn down.

Until the mid-1980s, the museum functioned primarily as a diversified set of galleries and was open only during the summer. In the 1980s, the museum began evolving into a professionally managed institution. The Board of Trustees raised $6.4 million and hired an English design team experienced with Thoroughbred racing to completely renovate the building and develop historical galleries covering three centuries of Thoroughbred racing in America. The renovation took ten months, and the building reopened on July 14, 1988.

In 1991, the museum adopted its first mission statement, hired its first professional educator and adopted its first long-range plan. Formal outreach programs began in 1996, with traveling Hall of Fame kiosks. An interactive traveling exhibit for children, the Discovery Paddock, was introduced the following year. Curriculum materials and educational programs for schools, public programs for the adult audience and a museum website also were introduced during this period.

Between 1999 and 2000, a major renovation and a ten-thousand-square-foot expansion of the physical plant costing $18 million improved collections

storage and created a changing exhibition space, a curatorial workroom and a Children's Gallery. The story line of the semipermanent historical galleries also expanded to include twentieth-century history and current events in racing. Extensive audio and video presentations, as well as interactive exhibits for families and adults, have been added throughout the museum.

During the past twenty years, there has been tremendous change in all areas of museum operations. The unique horse racing simulator was developed and opened to the public in 2006.

Sixty years after its founding, the National Museum of Racing and Hall of Fame continues to be a dynamic part of the vibrant sport it celebrates.

Brien Bouyea
Communications Officer
National Museum of Racing and Hall of Fame

Appendix A

Stakes Races as of 2010

Grade I

Alabama Stakes
Alfred G. Vanderbilt Handicap
Ballerina Handicap
Diana Handicap
Forego Handicap
Go for Wand Handicap
Hopeful Stakes
King's Bishop Stakes
Personal Ensign Stakes
Ruffian Handicap
Spinaway Stakes
Sword Dancer Handicap
Test Stakes
Travers Stakes
Whitney Handicap
Woodward Stakes

Grade II

Adirondack Stakes
Amsterdam Stakes

Ballston Spa Handicap
Bernard Baruch Handicap
Fourstardave Handicap
Honorable Miss Handicap
Jim Dandy Stakes
Lake George Stakes
Lake Placid Handicap
National Museum of Racing Hall of Fame Stakes
Sanford Stakes
Saratoga Special Stakes

GRADE III
Glens Falls Handicap
Saranac Stakes
Schuylerville Stakes
Victory Ride Stakes
With Anticipation Stakes

UNGRADED STAKES
Curlin Stakes
De La Rose Stakes
Funny Cide Stakes
John Morrissey Stakes
Saratoga Dew Stakes
Union Avenue Stakes

STEEPLECHASE
New York Turf Writers Cup Handicap (Grade I)
A.P. Smithwick Memorial Handicap (Grade II)

Appendix B

WINNERS OF THE TRAVERS STAKES

Year	Horse	Jockey	Trainer	Owner	Time
2010	Afleet Express	Javier Castellano	Jimmy Jerkens	Gainesway Farm	2:03.28
2009	Summer Bird	Kent Desormeaux	Tim Ice	Kalarikkal & Vilasini Jayaraman	2:02.83
2008	Colonel John	Garrett K. Gomez	Eoin G. Harty	WinStar Farm	2:03.20
2007	Street Sense	Calvin Borel	Carl Nafzger	James B. Tafel	2:02.69
2006	Bernardini	Javier Castellano	Thomas Albertrani	Darley Stable	2:01.60
2005	Flower Alley	John Velazquez	Todd A. Pletcher	Melnyk Racing Stables	2:02.76
2004	Birdstone	Edgar Prado	Nick Zito	Marylou Whitney Stables	2:02.45
2003	Ten Most Wanted	Pat Day	Wallace Dollase	J. Paul Reddam	2:02.14
2002	Medaglia d'Oro	Jerry Bailey	Robert J. Frankel	Edmund A. Gann	2:02.53
2001	Point Given	Gary Stevens	Bob Baffert	The Thoroughbred Corp.	2:01.40
2000	Unshaded	Shane Sellers	Carl Nafzger	James B. Tafel	2:02.59
1999	Lemon Drop Kid	Jose Santos	Flint S. Schulhofer	Jeanne G. Vance	2:02.00
1998	Coronado's Quest	Mike E. Smith	C.R. McGaughey III	Stuart S. Janney III	2:03.40
1997	Deputy Commander	Chris McCarron	Wallace Dollase	Horizon Stable	2:04.00
1996	Will's Way	Jorge F. Chavez	H. James Bond	William Clifton Jr.	2:02.40
1995	Thunder Gulch	Gary Stevens	D. Wayne Lukas	Michael Tabor	2:03.40
1994	Holy Bull	Mike E. Smith	Warren A. Croll Jr.	Warren A. Croll Jr.	2:02.00

Winners of the Travers Stakes

Year	Horse	Jockey	Trainer	Owner	Time
1993	Sea Hero	Jerry Bailey	MacKenzie Miller	Rokeby Stable	2:01.80
1992	Thunder Rumble	Herb McCauley	Richard O'Connell	Braeburn Farm	2:00.80
1991	Corporate Report	Chris McCarron	D. Wayne Lukas	William T. Young	2:01.20
1990	Rhythm	Craig Perret	C.R. McGaughey III	Ogden Phipps	2:02.60
1989	Easy Goer	Pat Day	C.R. McGaughey III	Ogden Phipps	2:00.80
1988	Forty Niner	Chris McCarron	Woody Stephens	Claiborne Farm	2:01.40
1987	Java Gold	Pat Day	MacKenzie Miller	Rokeby Stable	2:02.00
1986	Wise Times	Jerry Bailey	Phil Gleaves	R.L. Reineman Stables	2:03.40
1985	Chief's Crown	Angel Cordero Jr.	Roger Laurin	Star Crown Stables	2:01.20
1984	Carr de Naskra	Laffit Pincay Jr.	Richard J. Lundy	Virginia Kraft Payson	2:02.60
1983	Play Fellow	Pat Day	Harvey L. Vanier	Carl Lauer	2:01.00
1982	Runaway Groom	Jeffrey Fell	John DiMario	Albert J. Coppola	2:02.60
1981	Willow Hour	Eddie Maple	James E. Picou	Marcia W. Schott	2:03.60
1980	Temperence Hill	Eddie Maple	Joseph B. Cantey	Loblolly Stable	2:02.80
1979	General Assembly	Jacinto Vasquez	Leroy Jolley	Bertram R. Firestone	2:00.00
1978	Alydar	Jorge Velasquez	John M. Veitch	Calumet Farm	2:02.00
1977	Jatski	Sam Maple	William Cole	William Murray	2:01.60

151

Year	Horse	Jockey	Trainer	Owner	Time
1976	Honest Pleasure	Craig Perret	Leroy Jolley	Bertram R. Firestone	2:00.20
1975	Wajima	Braulio Baeza	Stephen A. DiMauro	East-West Stable	2:02.00
1974	Holding Pattern	Michael Miceli	James J. Sarner Jr.	John Gerbas Jr.	2:05.20
1973	Annihilate 'Em	Ron Turcotte	Douglas Davis Jr.	Patricia B. Blass	2:02.40
1972	Key to the Mint	Braulio Baeza	J. Elliott Burch	Rokeby Stable	2:01.20
1971	Bold Reason	Laffit Pincay Jr.	Angel Penna Sr.	William A. Levin	2:02.40
1970	Loud	Jacinto Vasquez	James W. Maloney	William Haggin Perry	2:01.00
1969	Arts and Letters	Braulio Baeza	J. Elliott Burch	Rokeby Stable	2:01.60
1968	Chompion	Jean Cruguet	Ivor G. Balding	C.V. Whitney	2:04.80
1967	Damascus	Bill Shoemaker	Frank Y. Whiteley Jr.	Edith W. Bancroft	2:01.60
1966	Buckpasser	Braulio Baeza	Edward A. Neloy	Ogden Phipps	2:01.60
1965	Hail to All	Johnny Sellers	Eddie Yowell	Zelda Cohen	2:02.20
1964	Quadrangle	Manuel Ycaza	J. Elliott Burch	Rokeby Stable	2:04.40
1963	Crewman	Eric Guerin	Bert Mulholland	George D. Widener Jr.	2:20.40
1962	Jaipur	Bill Shoemaker	Bert Mulholland	George D. Widener Jr.	2:01.60
1961	Beau Prince	Steve Brooks	Horace A. Jones	Calumet Farm	2:03.00
1960	Tompion	Bill Hartack	John J. Greely Jr.	C.V. Whitney	2:03.40

Winners of the Travers Stakes

Year	Horse	Jockey	Trainer	Owner	Time
1959	Sword Dancer	Manuel Ycaza	J. Elliott Burch	Brookmeade Stable	2:04.20
1958	Piano Jim	Bobby Ussery	Oscar White	Walter M. Jeffords	2:05.80
1957	Gallant Man	Bill Shoemaker	John A. Nerud	Ralph Lowe	2:04.00
1956	Oh Johnny	Hedley Woodhouse	Norman R. McLeod	Mrs. Wallace Gilroy	2:06.20
1955	Thinking Cap	Paul J. Bailey	Henry S. Clark	Christiana Stable	2:06.40
1954	Fisherman	Hedley Woodhouse	Sylvester Veitch	C.V. Whitney	2:06.00
1953	Native Dancer	Eric Guerin	William C. Winfrey	Alfred G. Vanderbilt II	2:05.60
1952	One Count	Eric Guerin	Oscar White	Mrs. Walter M. Jeffords	2:07.40
1951	Battlefield	Eddie Arcaro	Bert Mulholland	George D. Widener, Jr.	2:06.20
1950	Lights Up	George Hettinger	Bert Mulholland	George D. Widener, Jr.	2:03.00
1949	Arise	Con Errico	James C. Bentley	Addison Stable	2:06.20
1948	Ace Admiral	Ted Atkinson	James W. Smith	Maine Chance Farm	2:05.00
1947	Young Peter	Thomas May	George M. Odom	Cornelia Gerry	2:06.20
1946	Natchez	Ted Atkinson	Oscar White	Mrs. Walter M. Jeffords	2:08.00
1945	Adonis	Conn McCreary	Willie Booth	William G. Helis	2:02.80
1944	By Jimminy	Eddie Arcaro	James W. Smith	Alfred P. Parker	2:03.40
1943	Eurasian	Steve Brooks	Sol Rutchick	Mill River Stable	2:03.80

Year	Horse	Jockey	Trainer	Owner	Time
1942	Shut Out	Eddie Arcaro	John M. Gaver Sr.	Greentree Stable	2:04.40
1941	Whirlaway	Alfred Robertson	Ben A. Jones	Calumet Farm	2:05.80
1940	Fenelon	James Stout	Jim Fitzsimmons	Belair Stud	2:04.40
1939	Eight Thirty	Harry Richards	Bert Mulholland	George D. Widener Jr.	2:06.60
1938	Thanksgiving	Eddie Arcaro	Max Hirsch	Mrs. Parker Corning	2:03.60
1937	Burning Star	Wayne D. Wright	John J. Greely	Shandon Farm	2:04.80
1936	Granville	James Stout	Jim Fitzsimmons	Belair Stud	2:05.80
1935	Gold Foam	Silvio Coucci	J.M. Milburn	Starmount Stable	2:04.60
1934	Observant	Lee Humphries	Max Hirsch	Morton L. Schwartz	2:05.60
1933	Inlander	Robert Jones	Robert A. Smith	Brookmeade Stable	2:08.00
1932	War Hero	John Gilbert	George Conway	Glen Riddle Farm	2:05.80
1931	Twenty Grand	Linus McAtee	James G. Rowe Jr.	Greentree Stable	2:04.60
1930	Jim Dandy	Frank Baker	James B. McKee	Chaffee Earl	2:08.00
1929	Beacon Hill	Alfred Robertson	James G. Rowe Jr.	Harry P. Whitney	2:04.20
1928	Petee-Wrack	Steve O'Donnell	Willie Booth	John R. Macomber	2:08.00
1927	Brown Bud	Laverne Fator	A. Gunther	Frederick Johnson	2:05.60
1926	Mars	Frank Coltiletti	Scott P. Harlan	Walter M. Jeffords	2:04.60

Winners of the Travers Stakes

Year	Horse	Jockey	Trainer	Owner	Time
1925	Dangerous	Clarence Kummer	William B. Duke	Gifford A. Cochran	2:10.80
1924	Sun Flag	Frank Keogh	Carroll H. Shilling	Gifford A. Cochran	2:04.40
1923	Wilderness	Benny Marinelli	Thomas J. Healey	Richard T. Wilson Jr.	2:04.00
1922	Little Chief	Laverne Fator	Sam Hildreth	Rancocas Stable	2:13.40
1921	Sporting Blood	Lucien Lyke	Willie Booth	Redstone Stable	2:05.80
1920	Man o' War	Andy Schuttinger	Louis Feustel	Glen Riddle Farm	2:01.80
1919	Hannibal	Lavelle Ensor	Thomas J. Healey	Richard T. Wilson Jr.	2:02.80
1918	Sun Briar	William Knapp	Henry McDaniel	Willis Sharpe Kilmer	2:03.20
1917	Omar Khayyam	James Butwell	Richard F. Carmen	Wilfrid Viau	2:08.80
1916	Spur	Johnny Loftus	James H. McCormick	James Butler	2:05.00
1915	Lady Rotha	Mack Garner	A.J. Goldsborough	Andrew Miller	2:11.40
1914	Roamer	James H. Butwell	A.J. Goldsborough	Andrew Miller	2:04.00
1913	Rock View	Thomas McTaggart	Louis Feustel	August Belmont Jr.	2:06.60
1910	Dalmatian	Carroll H. Shilling	Sam Hildreth	Sam Hildreth	2:10.00
1909	Hilarious	Richard Scoville	James G. Rowe Sr.	James R. Keene	2:06.00
1908	Dorante	J. Lee	Rollie Colston Jr.	F.A. Forsythe	2:09.60
1907	Frank Gill	Joe Notter	J.I. Smith	J.L. McGinnis	2:07.00

YEAR	HORSE	JOCKEY	TRAINER	OWNER	TIME
1906	Gallavant	Walter Miller	Thomas J. Healey	Richard T. Wilson Jr.	2:08.20
1905	Dandelion	Willie Shaw	John E. Madden	Frank R. Hitchock	2:08.00
1904	Broomstick	Thomas H. Burns	Robert Tucker	Samuel S. Brown	2:06.80
1903	Ada Nay	Frank O'Neill	A. Jack Joyner	James B.A. Haggin	1:57.00
1902	Hermis	Ted Rice	John H. McCormack	H.M. Ziegler	1:54.80
1901	Blues	Willie Shaw	Thomas Welch	C. Fleischmann Sons	1:56.60
1897	Rensselaer	Fred Taral	Henry Harris	John E. McDonald	1:56.60
1895	Liza	Henry Griffin	John Huggins	Pierre Lorillard IV	1:55.50
1894	Henry of Navarre	Fred Taral	Byron McClelland	Byron McClelland	2:10.25
1893	Stowaway	Lawrence McDermott	H.H. Brandt	Woodland Stable	2:10.75
1892	Azra	Alonzo Clayton	John H. Morris	Bashford Manor Stable	2:43.75
1891	Vallera	R. Williams	Enoch Wishard	Scoggan Bros	2:49.00
1890	Sir John	Marty Bergen	Frank McCabe	Dwyer Brothers Stable	2:39.00
1889	Long Dance	Shelby "Pike" Barnes	G.M. Rye	G.M. Rye	3:08.75
1888	Sir Dixon	Jim McLaughlin	Frank McCabe	Dwyer Brothers Stable	3:07.75
1887	Carey	Harry Blaylock	Edward Corrigan	Edward Corrigan	3:17.75

Winners of the Travers Stakes

Year	Horse	Jockey	Trainer	Owner	Time
1886	Inspector B.	Jim McLaughlin	Frank McCabe	Dwyer Brothers Stable	3:10.25
1885	Bersan	John Spellman	Green B. Morris	Green B. Morris	3:08.25
1884	Rataplan	William Fitzpatrick	F. Midgeley	Norman W. Kittson	3:07.50
1883	Barnes	Jim McLaughlin	James G. Rowe Sr.	Dwyer Brothers Stable	3:18.00
1882	Carley	George Quantrell	H. Welch	A. Burnham	3:28.75
1881	Hindoo	Jim McLaughlin	James G. Rowe Sr.	Dwyer Brothers Stable	3:07.50
1880	Grenada	Lloyd Hughes	R. Wyndham Walden	George L. Lorillard	3:12.50
1879	Falsetto	Isaac Burns Murphy	Eli Jordan	J.W. Hunt Reynolds	3:09.25
1878	Duke of Magenta	Lloyd Hughes	R. Wyndham Walden	George L. Lorillard	3:08.00
1877	Baden-Baden	Tom Sayres	James Williams	William Astor Jr.	3:15.50
1876	Sultana	William Hayward	J. McClelland	August Belmont	3:15.50
1875	D'Artagnan	George Barbee	J.B. Pryor	J.A. Grinstead	3:06.50
1874	Attila	George Barbee	William Pryor	Pierre Lorillard IV	3:09.50
1873	Tom Bowling	Robert Swim	Ansel Williamson	Hal Price McGrath	3:09.75
1872	Joe Daniels	James G. Rowe Sr.	David McDaniel	David McDaniel	3:08.25
1871	Harry Bassett	W. Miller	David McDaniel	David McDaniel	3:21.60
1870	Kingfisher	Charles Miller	Rollie Colston	Daniel Swigert	3:15.25

YEAR	HORSE	JOCKEY	TRAINER	OWNER	TIME
1869	Glenelg	Charles Miller	Jacob Pincus	August Belmont	3:14.00
1868	The Banshee	Smith	J.H. Davis	John M. Clay	3:10.75
1867	Ruthless	Gilbert W. Patrick	A. Jack Minor	Francis Morris	3:18.25
1866	Merrill	Abe Hawkins	Ansel Williamson	Robert A. Alexander	3:29.00
1865	Maiden	W. Sewell	T.G. Moore	T.G. Moore	3:18.50
1864	Kentucky	Gilbert W. Patrick	A. Jack Minor	J. Hunter / W.R. Travers	3:18.75

Appendix C

WINNERS OF THE
WHITNEY HANDICAP

Year	Horse	Age	Jockey	Trainer	Owner	Time
2010	Blame	4	Garrett Gomez	Albert M. Stall Jr.	Adele B. Dilschneider	1:48.88
2009	Bullsbay	5	Jeremy Rose	H. Graham Motion	Mitchell Ranch LLC	1:48.12
2008	Commentator	7	John Velazquez	Nick Zito	Tracy Farmer	1:50.23
2007	Lawyer Ron	4	John R. Velazquez	Todd A. Pletcher	Hines Racing LLC	1:46.64
2006	Invasor	4	Fernando Jara	Kiaran McLaughlin	Shadwell Racing	1:49.06
2005	Commentator	4	Gary Stevens	Nick Zito	Tracy Farmer	1:48.33
2004	Roses in May	4	Edgar Prado	Dale L. Romans	Ken & Sarah Ramsey	1:48.54
2003	Medaglia d'Oro	4	Jerry Bailey	Robert J. Frankel	Edmund A. Gann	1:47.69
2002	Left Bank	5	John R. Velazquez	Todd A. Pletcher	Michael B. Tabor	1:47.04
2001	Lido Palace	4	Jerry Bailey	Robert J. Frankel	John Amerman	1:47.94
2000	Lemon Drop Kid	4	Edgar Prado	Scotty Schulhofer	Jeanne G. Vance	1:48.30
1999	Victory Gallop	4	Jerry Bailey	Elliott Walden	Prestonwood Farm	1:48.66
1998	Awesome Again	4	Pat Day	Patrick B. Byrne	Stronach Stables	1:49.71
1997	Will's Way	4	Jerry Bailey	H. James Bond	Rudlein Stable	1:48.37
1996	Mahogany Hall	5	Jose Santos	James Baker	Woodlyn Farm	1:48.60
1995	Unaccounted For	4	Pat Day	Scotty Schulhofer	Morven Stud	1:49.20
1994	Colonial Affair	4	Jose Santos	Scotty Schulhofer	Centennial Farms	1:48.60

Winners of the Whitney Handicap

Year	Horse	Age	Jockey	Trainer	Owner	Time
1993	Brunswick	4	Mike E. Smith	Anthony Margotta	Jerry Denker	1:47.40
1992	Sultry Song	4	Jerry Bailey	Patrick Kelly	Live Oak Racing	1:47.20
1991	In Excess	4	Gary Stevens	Bruce L. Jackson	Jack J. Munari	1:48.00
1990	Criminal Type	5	Gary Stevens	D. Wayne Lukas	Calumet Farm	1:48.60
1989	Easy Goer	3	Pat Day	C.R. McGaughey III	Ogden Phipps	1:47.40
1988	Personal Ensign	4	Randy Romero	C.R. McGaughey III	Ogden Phipps	1:47.80
1987	Java Gold	3	Pat Day	MacKenzie Miller	Rokeby Stable	1:48.40
1986	Lady's Secret	4	Pat Day	D. Wayne Lukas	Eugene V. Klein	1:49.80
1985	Track Barron	4	Angel Cordero Jr.	LeRoy Jolley	Peter M. Brant	1:47.60
1984	Slew o'Gold	4	Angel Cordero Jr.	John O. Hertler	Equusequity Stable	1:48.20
1983	Island Whirl	5	Ed Delahoussaye	Laz Barrera	Elcee-H Stable	1:48.40
1982	Silver Buck	4	Don MacBeth	J. Elliott Burch	C.V. Whitney	1:47.80
1981	Fio Rito	6	Leslie Hulet	Michael Ferraro	Raymond LeCesse	1:48.00
1980	State Dinner	5	Ruben Hernandez	J. Elliott Burch	C.V. Whitney	1:48.20
1979	Star de Naskra	4	Jeffrey Fell	Richard D. Ferris	Caryle J. Lancaster	1:47.60
1978	Alydar	3	Jorge Velasquez	John M. Veitch	Calumet Farm	1:47.40
1977	Nearly On Time	3	Steve Cauthen	LeRoy Jolley	Mrs. Moody Jolley	1:49.40

YEAR	HORSE	AGE	JOCKEY	TRAINER	OWNER	TIME
1976	Dancing Gun	4	Roger Velez	Laz Barrera	Gedney Farms	1:50.00
1975	Ancient Title	5	Sandy Hawley	Keith L. Stucki Sr.	Ethel Kirkland	1:48.20
1974	Tri Jet	5	Laffit Pincay Jr.	Charles R. Parke	Fred W. Hooper	1:47.00
1973	Onion	4	Jacinto Vasquez	H. Allen Jerkens	Hobeau Farm	1:49.20
1972	Key to the Mint	3	Braulio Baeza	J. Elliott Burch	Rokeby Stable	1:49.20
1971	Protanto	4	Jorge Velasquez	MacKenzie Miller	Cragwood Stables	1:49.40
1970	Judgable	3	Robert Woodhouse	Herbert Nadler	Saul Nadler	1:48.40
1969	Verbatim	4	Pete Anderson	James P. Conway	Elmendorf Farm	1:50.00
1968	Dr. Fager	4	Braulio Baeza	John A. Nerud	Tartan Stable	1:48.80
1967	Stupendous	4	Eddie Belmonte	Edward A. Neloy	Wheatley Stable	1:48.20
1966	Staunchness	4	Ernest Cardone	Victor J. Nickerson	Red Oak Stable	1:50.20
1965	Kelso	8	Ismael Valenzuela	Carl Hanford	Bohemia Stable	1:49.80
1964	Gun Bow	4	Walter Blum	Edward A. Neloy	Gedney Farms	1:49.20
1963	Kelso	6	Ismael Valenzuela	Carl Hanford	Bohemia Stable	1:50.40
1962	Carry Back	4	Johnny Sellers	Jack A. Price	Katherine Price	1:50.00
1961	Kelso	4	Eddie Arcaro	Carl Hanford	Bohemia Stable	1:48.00
1960	Warhead	5	Mike Sorrentino	Kay Erik Jensen	Mabel C. Scholtz	1:51.00

Winners of the Whitney Handicap

Year	Horse	Age	Jockey	Trainer	Owner	Time
1959	Plion	4	Manuel Ycaza	Tom Jolley	Edward M. Potter	1:53.00
1958	Cohoes	4	John Ruane	John M. Gaver Sr.	Greentree Stable	1:51.60
1957	Kingmaker	4	Bobby Ussery	Frank I. Wright	Happy Hill Farm	1:52.80
1956	Dedicate	4	William Boland	G. Carey Winfrey	Jan Burke	1:49.80
1955	First Aid	5	Hedley Woodhouse	J. Elliott Burch	Brookmeade Stable	1:51.60
1954	Social Outcast	4	Eric Guerin	William C. Winfrey	Alfred G. Vanderbilt II	2:04.40
1953	Tom Fool	4	Ted Atkinson	John M. Gaver Sr.	Greentree Stable	2:05.40
1952	Counterpoint	4	David Gorman	Sylvester Veitch	C.V. Whitney	2:05.60
1951	One Hitter	5	Ted Atkinson	John M. Gaver Sr.	Greentree Stable	2:05.00
1950	Piet	5	Nick Combest	R. Emmett Potts	BoMar Stable	2:06.60
1949	Round View	6	Sebastian Perez	Hollie Hughes	Sanford Stud Farms	2:06.60
1948	Gallorette	6	Arnold Kirkland	Edward A. Christmas	William L. Brann	2:05.20
1947	Rico Monte	5	Ruperto Donoso	Horatio Luro	W. Arnold Hanger	2:02.60
1946	Stymie	5	Basil James	Hirsch Jacobs	Ethel D. Jacobs	2:07.40
1945	Trymenow	3	Herb Lindberg	Oscar White	Walter M. Jeffords Sr.	2:02.20
1944	Devil Diver	5	Eddie Arcaro	John M. Gaver Sr.	Greentree Stable	2:02.00
1943	Bolingbroke	6	Herb Lindberg	Walter Burrows	Townsend B. Martin	2:02.00

YEAR	HORSE	AGE	JOCKEY	TRAINER	OWNER	TIME
1942	Swing and Sway	4	Don Meade	John M. Gaver Sr.	Greentree Stable	2:05.40
1941	Fenelon	4	James Stout	James Fitzsimmons	Belair Stud	2:06.40
1940	Challedon	4	George Woolf	Louis J. Schaefer	William L. Brann	2:03.20
1939	Eight Thirty	3	Harry Richards	Bert Mulholland	George D. Widener Jr.	2:06.20
1938	War Admiral	4	Wayne D. Wright	George Conway	Glen Riddle Farm	2:03.80
1937	Esposa	5	Nick Wall	Matthew P. Brady	William Ziegler Jr.	2:05.20
1936	Discovery	5	John Bejshak	Bud Stotler	Alfred G. Vanderbilt II	2:06.80
1935	Discovery	4	John Bejshak	Bud Stotler	Alfred G. Vanderbilt II	2:04.80
1934	Discovery	3	Don Meade	Bud Stotler	Alfred G. Vanderbilt II	2:07.80
1933	Caesar's Ghost	3	Dominick Bellizzi	Jack J. Connors	Brookmeade Stable	2:10.80
1932	Equipoise	4	Raymond Workman	Thomas J. Healey	C.V. Whitney	2:05.60
1931	St. Brideaux	3	Linus McAtee	James G. Rowe Jr.	Greentree Stable	2:05.00
1930	Whichone	3	Raymond Workman	James G. Rowe Jr.	Harry Payne Whitney	2:04.00
1929	Bateau	4	Eddie Ambrose	Scott P. Harlan	Walter M. Jeffords Sr.	2:09.40
1928	Black Maria	5	Laverne Fator	William H. Karrick	William R. Coe	2:06.00

Appendix D

WINNERS OF THE
ALABAMA STAKES

YEAR	HORSE	JOCKEY	TRAINER	OWNER	TIME
2010	Blind Luck	Joel Rosario	Jerry Hollendorfer	Hollendorfer/Dedomenico/Carver/Abruzzo	2:03.89
2009	Careless Jewel	Robert Landry	Josie Carroll	Donver Stable	2:03.24
2008	Proud Spell	Gabriel Saez	Larry Jones	Brereton Jones	2:04.08
2007	Lady Joanne	Calvin Borel	Carl Nafzger	Bentley Smith	2:03.62
2006	Pine Island	Javier Castellano	C.R. McGaughey III	Phipps Stable	2:02.87
2005	Sweet Symphony	Jerry D. Bailey	William I. Mott	Kinsman Stable	2:04.45
2004	Society Selection	Cornelio Velasquez	H. Allen Jerkens	Marjorie & Irving Cowan	2:02.60
2003	Island Fashion	John R. Velazquez	Barclay Tagg	Jeffrey L. Nielsen	2:05.00
2002	Farda Amiga	Pat Day	Paulo Lobo	Escolastica Stable et al.	2:04.60
2001	Flute	Jerry D. Bailey	Robert J. Frankel	Juddmonte Farm	2:01.80
2000	Jostle	Mike E. Smith	John C. Servis	Fox Hill Farms Inc.	2:04.60
1999	Silverbulletday	Jerry D. Bailey	Bob Baffert	Michael E. Pegram	2:02.60
1998	Banshee Breeze	Jerry D. Bailey	Carl Nafzger	James B. Tafel	2:03.40
1997	Runup the Colors	Jerry D. Bailey	Neil J. Howard	William S. Farish III	2:02.20
1996	Yanks Music	John R. Velazquez	Leo O'Brien	M. Fennessy/A. Cooper	2:03.00
1995	Pretty Discreet	Mike E. Smith	William Terrill	E. Paul Robsham	2:02.00

Winners of the Alabama Stakes

YEAR	HORSE	JOCKEY	TRAINER	OWNER	TIME
1994	Heavenly Prize	Mike E. Smith	C.R. McGaughey III	Ogden Phipps	2:03.20
1993	Sky Beauty	Mike E. Smith	H. Allen Jerkens	Georgia E. Hofmann	2:03.40
1992	November Snow	Chris Antley	H. Allen Jerkens	Earle I. Mack	2:02.60
1991	Versailles Treaty	Angel Cordero Jr.	C.R. McGaughey III	Cynthia Phipps	2:02.40
1990	Go for Wand	Randy Romero	William Badget Jr.	Christiana Stable	2:00.80
1989	Open Mind	Angel Cordero Jr.	D. Wayne Lukas	Eugene V. Klein	2:04.20
1988	Maplejinsky	Angel Cordero Jr.	Philip G. Johnson	Susan Kaskel	2:01.80
1987	Up the Apalachee	Jorge Velasquez	George Arcenaux	J. Minos Simon	2:04.00
1986	Classy Cathy	Earlie Fires	C.R. McGaughey III	Edward A. Cox Jr.	2:04.20
1985	Mom's Command	Abigail Fuller	Edward T. Allard	Peter Fuller	2:03.20
1984	Life's Magic	Jorge Velasquez	D. Wayne Lukas	Eugene V. Klein	2:02.60
1983	Spit Curl	Jean Cruguet	Leroy Jolley	Peter M. Brant	2:02.40
1982	Broom Dance	Gregg McCarron	James W. Maloney	Christiana Stable	2:02.20
1981	Prismatical	Eddie Maple	Luis Barrera	Happy Valley Farm	2:02.40
1980	Love Sign	Ruben Hernandez	Sidney Watters Jr.	Stephen C. Clark Jr.	2:01.00
1979	It's in the Air	Jeffrey Fell	Lazaro S. Barrera	Harbor View Farm	2:01.40
1978	White Star Line	Michael Venezia	Woody Stephens	Newstead Farm	2:04.00

YEAR	HORSE	JOCKEY	TRAINER	OWNER	TIME
1977	Our Mims	Jorge Velasquez	John M. Veitch	Calumet Farm	2:03.00
1976	Optimistic Gal	Eddie Maple	Leroy Jolley	Diana M. Firestone	2:01.60
1975	Spout	Jean Cruguet	Victor J. Nickerson	Elmendorf Farm	2:04.00
1974	Quaze Quilt	Heliodoro Gustines	Charles R. Parke	Fred W. Hooper	2:02.60
1973	Desert Vixen	Jorge Velasquez	Thomas F. Root Sr.	Harry T. Mangurian Jr.	2:04.20
1972	Summer Guest	Jorge Velasquez	J. Elliott Burch	Rokeby Stable	2:03.40
1971	Lauries Dancer	Ron Turcotte	James C. Bentley	Helen G. Stollery	2:03.00
1970	Fanfreluche	Sandy Hawley	Yonnie Starr	Jean-Louis Levesque	2:03.80
1969	Shuvee	Jesse Davidson	Willard C. Freeman	Anne Minor Stone	2:06.40

EARLIER WINNERS

1873—Minnie	1921—Prudery
1874—Regardless	1922—Nedna
1875—Olitipa	1923—Untidy
1876—Merciless	1924—Priscilla Ruley
1877—Susquehanna	1925—Maid at Arms
1878—Belle	1926—Rapture
1879—Ferida	1927—Nimba
1880—Glidelia	1928—Nixie
1881—Thora	1929—Aquastella
1882—Belle of Runnymede	1930—Escutcheon
1883—Miss Woodford	1931—Risque
1884—Tolu	1932—Top Flight
1885—Ida Hope	1933—Barn Swallow
1886—Millie	1934—Hindu Queen
1887—Grisette	1935—Alberta
1888—Bella B.	1936—Floradora
1889—Princess Bowling	1937—Regal Lily
1890—Sinaloa II	1938—Handcuff
1891—Sallie McClelland	1939—War Plumage
1892—Ignite	1940—Salaminia
1897—Poetess	1941—War Wizard
1901—Morningside	1942—Vagrancy
1902—Par Excellence	1943—Stefanita
1903—Stamping Ground	1944—Vienna
1904—Beldame	1945—Sicily
1905—Tradition	1946—Hypnotic
1906—Running Water	1947—But Why Not
1907—Kennyetto	1948—Compliance
1908—Mayfield	1949—Adile
1909—Maskette	1950—Busanda
1910—Ocean Bound	1951—Kiss Me Kate
1913—Flying Fairy	1952—Lily White
1914—Addie M.	1953—Sabette
1915—Waterblossom	1954—Parlo
1916—Malachite	1955—Rico Reto
1917—Sunbonnet	1956—Tournure
1918—Eyelid	1957—Here and There
1919—Vexatious	1958—Tempted
1920—Cleopatra	1959—High Bid

Appendix D

1960—Make Sail
1961—Primonetta
1962—Firm Policy
1963—Tona
1964—Miss Cavandish
1965—What a Treat
1966—Natashka
1967—Gamely
1968—Gay Matelda

Notes

Chapter 1

1. *New York Times*, May 14, 1905.
2. Claudia Gryvatz Copquin, *The Neighborhoods of Queens* (New Haven, CT: Yale University Press, 2007), 148.
3. www.encyclopedia.com/topic/horse_racing.aspx.
4. wikipedia.org.

Chapter 2

5. www.oldebryaninn.com/restaurant/history.

Chapter 3

6. www.boxinggyms.com.
7. *New York Times*, June 7, 1857.
8. *New York Daily Tribune*, May 2, 1878.

CHAPTER 4

9. Hugh Bradley, *Such Was Saratoga* (New York: Doubleday, Doran & Co., 1940).

10. John Bartles, *Saratoga Stories, Gangsters, Gamblers and Racing Legends* (Lexington, KY: Eclipse Press, Blood Horse Publications, 2007), 23.

11. *New York Times*, March 15, 1885.

12. Edward Clinton Hotaling, *They're Off! Horse Racing at Saratoga* (Syracuse, NY: Syracuse University Press, 1995).

13. Bartles, *Saratoga Stories*.

14. Bradley, *Such Was Saratoga*.

15. *New York Times*, 1864.

16. *Life*, June 26, 1963.

17. Bradley, *Such Was Saratoga*.

CHAPTER 5

18. *New York Times*, June 3, 1872.

19. Ibid., May 2, 1878.

20. Ibid., May 6, 1878.

21. Ibid., July 26, 1878.

22. Ibid., August 12, 1881.

23. *Life*, June 26, 1963.

24. *New York Times*, August 12, 1881.

25. Ibid., November 15, 1894.

26. Ibid., August 8, 1894.

27. *Life*, June 26, 1963.

CHAPTER 6

28. Ibid.

29. Ibid.

CHAPTER 7

30. *New York Times*, August 8, 1920.

31. *Albany Times Union*.

32. horseracing.about.com/od/famoushorses/l/blmanwar.htm.

CHAPTER 8

33. *New York Times*, August 21, 1921.
34. Ibid., August 8, 1922.
35. Ibid.

CHAPTER 10

36. Ibid., August 31, 1939.

CHAPTER 11

37. Unofficial Thoroughbred Hall of Fame, Spiletta.com.
38. Ibid.

CHAPTER 12

39. *Time*, June 1963.
40. Unofficial Thoroughbred Hall of Fame, Spiletta.com.
41. *Albany Times Union*, August 8, 1965.
42. Unofficial Thoroughbred Hall of Fame, Spiletta.com.
43. *Sports Illustrated*, September 6, 1965.
44. Ibid., August 25, 1969.

CHAPTER 13

45. *Daily Racing Form*, August 26, 1972.
46. *Sports Illustrated*, September 2, 1974.
47. Ibid.
48. Ibid.

CHAPTER 14

49. Ibid., August 14, 1978.
50. Ibid., August 27, 1979.
51. Ibid.

CHAPTER 15

52. *New York Times*, August 22, 1982.

CHAPTER 16

53. Ibid., August 25, 1996.
54. Ibid., August 20, 1997.
55. *Blood Horse*, June 27, 1995.
56. *Sports Illustrated*, August 19, 1997.
57. Ibid., January 3, 1999.

CHAPTER 17

58. *Sports Illustrated*, August 14, 1978.
59. NBCSports, August 30, 2008.
60. *USA Today*, August 24, 2008.

CHAPTER 18

61. WNYT, August 26, 2010.
62. Joe Palmer, "Saratoga, or the Horse at Home." In *This was Racing*, edited by Red Smith, A.S. Barnes and Company (n.p., 1953).

About the Author

K imberly Gatto is a professional writer specializing in equestrian and sports books. Her published works to date include four horse-related titles and several athlete biographies. Kim's work has been included in various publications, including the *Blood-Horse*, the *Chronicle of the Horse*, the *Equine Journal* and *Chicken Soup for the Horse Lover's Soul*. Gatto is an honors graduate of Boston Latin School and Wheaton College. A lifelong rider and horsewoman, she is the proud owner of a lovely off-the-track thoroughbred.

Visit us at
www.historypress.net

Printed in the USA
CPSIA information can be obtained
at www.ICGtesting.com
LVHW051009071023
760468LV00001B/2